THE LITTLE BOOK OF

Roy Thomas

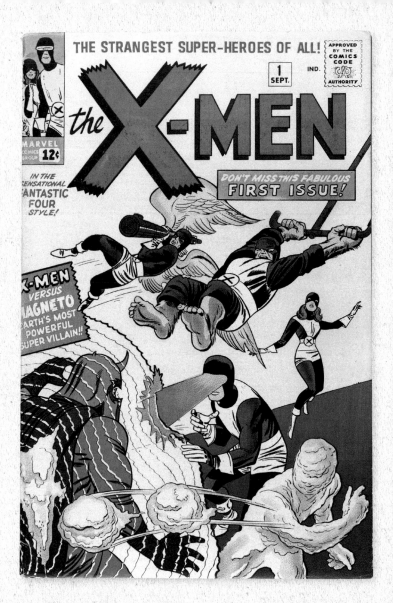

WHAT'S SO GREAT ABOUT THE X-MEN?

For their first decade-plus, chances are most Marvel readers would've answered the above question:

"Not much!"

Not that *X-Men* wasn't a great idea from the very beginning in 1963. It had everything going for it: the team supreme of Stan Lee (writer & editor) and Jack Kirby (artist & unofficial co-plotter), the same guys who'd made a smash hit out of *Fantastic Four*.

Plus, the X-Men were like a mash-up of the FF and Spider-Man: an assemblage of heroes wearing a group uniform, but all about the same age as Peter Parker.

They even had a colorful joint origin: They were all mutants— young people at the vanguard of a new breed of human, their powers coalescing in myriad astonishing ways, in the radiance of an atomic energy-influenced world. In the emerging Marvel Universe, it was already a given that, if you were exposed to radioactivity, like cosmic rays or gamma rays or the bite of a momentarily radioactive spider, you turned into a super hero! Or, in this case, a *quintet* of super heroes.

With all the above going for it, *X-Men* became a modest hit, as they searched for "good mutants" to join their merry conclave, and for "evil mutants" who had to be stopped from doing, well, *evil*. Professor X led the good guys; his arch-rival Magneto fronted the aptly named

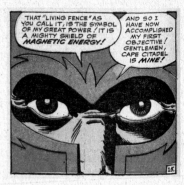

Brotherhood of Evil Mutants. And that's pretty much how the comic went for its first few years. Lee and Kirby's most memorable storyline centered on the Sentinels, giant robots programmed to capture all mutants, simply because they were *different* — and "different" can't be trusted. Readers were beginning to notice the *symbolism*.

Near the end of its initial 66-issue run, artist-phenom Neal Adams and the present writer rejuvenated the book a bit — but it was a case of too little, too late. Their title canceled, the X-Men seemed fated to be relegated to occasional guest shots, with one or another of them making a stab at his own solo series.

But then Marvel got lucky — and Marvel's fans got even luckier.

In a 1974 meeting between Stan Lee and two or three others of us, someone suggested Marvel create a team of super heroes from several different countries…especially from ones where we hoped to sell additional comics! My own suggestion turned that into a return of *X-Men* — a couple of the original mutants, plus several new ones from this country or that. When the revival debuted in 1975, under writer Len Wein (soon followed by long-termer Chris Claremont) and

X-MEN No. 1

Page 4 and opposite: *Cover; pencils, Jack Kirby; inks, Sol Brodsky. Interiors, "X-Men!"; script, Stan Lee; pencils, Jack Kirby; inks, Paul Reinman. September 1963.* Stan Lee recounts telling publisher Martin Goodman, in an interview from the Archives of American Television: "'They're mutants. They were born that way. I don't have to explain anything.' [Goodman] said, 'Nobody is gonna know what a mutant is.'…So I said to him, 'Okay. Instead of The Mutants we're gonna call it The X-Men.' And he said, 'Yeah, that's a good name.' I thought to myself, 'If nobody is gonna know what a mutant is, how is anybody gonna know what an X-Man is?'"

IMAGE DUPLICATOR

Right: *Photograph, John Loengard; artist Roy Lichtenstein with his painting,* Image Duplicator; *ca. 1963.* "Lichtenstein did no more or less for comics than Andy Warhol did for soup."
— Art Spiegelman

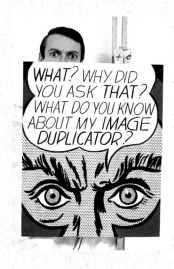

artist Dave Cockrum (succeeded later by John Byrne), the revitalized *X-Men* began its meteoric rise. Along the way, the notion of tagging the new mutants to countries that were keen on comics was forgotten (after all, newbie Colossus was from the U.S.S.R., and weather-wielding Storm from Kenya). Still, in the 1980s, *The X-Men* rivaled the preeminence of Spider-Man himself!

The mag's breakout star, of course, was Wolverine, the cut-and-slash Canadian…but, over the next couple of decades, he was followed by the likes of Phoenix (a couple of them)…Mystique…Rogue…Deadpool…Cable…Bishop…Gambit. *X-Men* titles spun off, split, and multiplied: *Uncanny X-Men…New Mutants…X-Factor…Excalibur…X-Force…Generation X…Exiles.* If you could put an "X" with it, it was probably a Marvel mutant title at one time or another!

The concept became so popular that it was the X-Men, rather than Spidey, who starred in the first real Marvel super hero movie, in 2000. If you count the Wolverine films and *Deadpool*, there've been ten X-Men flicks to date—with lots more coming!

If you'd told Stan Lee and his cohorts back in 1963—or 1970—

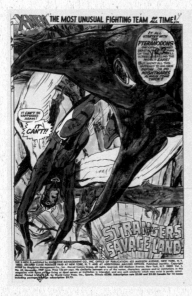

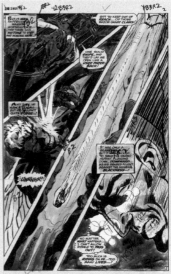

or even 1975—that *X-Men* would become one of Marvel's hottest properties…well, let's just say you'd soon have been sharing a war-room with a bunch of guys who thought they were Napoleon.

But, through mutation, it seems, *all* things are possible. Mutants are, by definition, the wave of the future—and never more so than at mighty Marvel Comics!

— ROY THOMAS

X-MEN No. 62
Above: *Interior color guide, "Strangers in a Savage Land!"; script, Roy Thomas; pencils, Neal Adams; inks, Tom Palmer; December 1969.* Roy Thomas and Neal Adams's *X-Men* was the last gasp of the first run of comics, but what a run they had!

X-MEN No. 50
Opposite: *Cover; pencils and inks, Jim Steranko; November 1968.* Polaris, aka Lorna Dane, gets her first luxuriant cover turn. Introduced as the daughter of Magneto (a plot point later reversed), she represented an early instance of the fruitful nature of mutantkind: Cool new characters with an X-gene could pop up at any time, and as time has proven, they did!

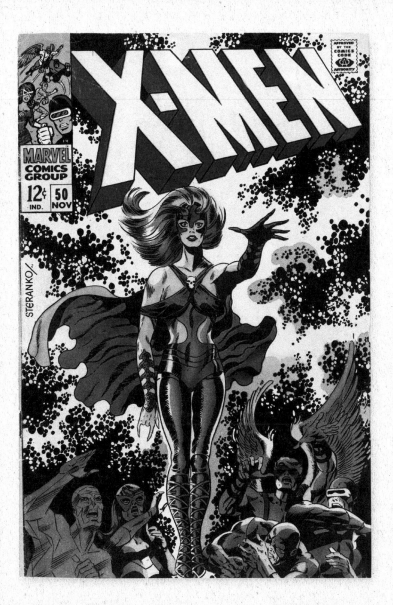

LEN WEIN WRITER EDITOR — CO-CREATORS — & **DAVE COCKRUM** ILLUSTRATOR | **GLYNIS WEIN** colorist | **JOHN COSTANZA** letterer

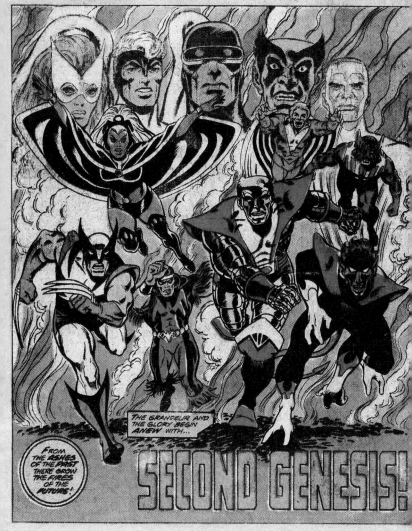

THE GRANDEUR AND THE GLORY BEGIN *ANEW* WITH...

FROM THE ASHES OF THE PAST THERE GROW THE FIRES OF THE FUTURE!

SECOND GENESIS!

WAS IST SO GROSSARTIG AN DEN X-MEN?

Wissen Sie, was die meisten Marvel-Leser zwanzig Jahre lang auf die obige Frage geantwortet hätten?

„Nicht viel!"

Dabei war die Serie *The X-Men*, die 1963 startete, ein wirklich großartiges Konzept. Und sie stammte von einem unschlagbaren Team: Stan Lee (Autor und Redakteur) und Jack Kirby (der Künstler, der inoffiziell auch die Handlung mitentwarf). Diese beiden waren es immerhin gewesen, die *The Fantastic Four* zum Erfolg gemacht hatten.

Außerdem waren die X-Men eine Art Mixtur aus den FF und Spider-Man: ein Heldenteam, das Uniformen trug, doch ungefähr so alt war wie Peter Parker.

Die X-Men besaßen sogar eine aufregende gemeinsame Herkunftsgeschichte: Sie waren allesamt Mutanten – und die Kinder der Wissenschaftler, die zwanzig Jahre zuvor an der Entwicklung der Atombombe mitgewirkt hatten. Im damals neuen Marvel-Universum gehörte es zu den Grundgesetzen, dass der Kontakt mit Radioaktivität – sei es nun kosmische Strahlung, Gammastrahlung oder der Biss einer vorübergehend radioaktiven Spinne – einen in einen Superhelden verwandelte! Oder in diesem Fall in ein ganzes Quintett aus Superhelden. (Nur ihr Anführer, Professor X, war eindeutig zu alt, um der Sohn amerikanischer Atomforscher zu sein.)

Durch all die genannten Pluspunkte wurde *The X-Men* ein gewisser Erfolg. Das Team suchte nach „guten Mutanten", die ihrer Gruppe beitreten sollten, und nach „bösen Mutanten", die man daran hindern wollte, nun ja, böse zu sein. Professor X war der Anführer der Guten, sein Erzrivale Magneto befehligte die zu Recht so genannte Bruderschaft der bösen Mutanten. Und das ist im Wesentlichen das,

worum es in der Serie in den ersten Jahren ging. Das denkwürdigste Abenteuer von Lee und Kirby handelte von den Sentinels, riesigen Robotern, die darauf programmiert waren, alle Mutanten gefangen zu nehmen – einfach deshalb, weil Mutanten *anders* waren und man Andersartigem nicht trauen konnte. Die Leser begannen zu ahnen, wofür dies im damaligen Amerika stand.

Gegen Ende der ersten, 66 Hefte umfassenden Serie erhielten der Starkünstler Neal Adams und der Autor dieser Zeilen die Aufgabe, *The X-Men* zu überarbeiten. Doch es war umsonst, die Reihe wurde eingestellt. Gelegentlich sah man die X-Men noch in anderen Titeln auftreten, einer oder zwei der Helden erschienen kurzzeitig in einer Soloserie.

Doch dann landete Marvel einen Volltreffer.

1974, in einer Besprechung mit Stan Lee und zwei oder drei von uns Autoren, schlug jemand ein Superheldenteam vor mit Mitgliedern aus unterschiedlichen Ländern ... vorzugsweise aus jenen Ländern, in denen Marvel mehr Comics verkaufen wollte. Ich machte daraufhin den Vorschlag, dass wir auf diese Weise die X-Men zurückbringen könnten – einige der ursprünglichen Mutanten plus einige neue aus diesem oder jenem Land. Das neue Team debütierte 1975 unter Autor Len Wein (bald abgelöst von Langzeitautor Chris Claremont) und Künstler Dave Cockrum (später ersetzt durch John Byrne), und für die Serie ging es steil nach oben. Dass die neuen Mutanten aus jenen Nationen stammen sollten, die potenzielle Absatzmärkte darstellten, wurde bald vergessen – immerhin kam der Neuling Colossus aus der UdSSR und die Mutantin Storm aus Kenia. Dennoch oder gerade deswegen wurden die X-Men in den 1980er-Jahren ähnlich populär wie Spider-Man!

Der Liebling der Leser war natürlich Wolverine, der nicht gerade zart besaitete Kanadier. In den weiteren Jahren folgten Mutanten wie Phoenix (mehrere Versionen davon) ... Mystique ... Rogue ... Deadpool ... Cable ... Bishop ... Gambit. Und aus *The X-Men* gingen etliche neue Reihen hervor: *Uncanny X-Men* ... *New Mutants* ... *X-Factor* ... *Excalibur* ... *X-Force* ... *Generation X* ... *Exiles*. Jedes Wort, das sich

mit einem „X" kombinieren ließ, war wahrscheinlich irgendwann einmal der Titel einer Marvel-Mutantenserie.

Das Konzept wurde so erfolgreich, dass es nicht Spidey, sondern die X-Men waren, die 2000 im ersten richtigen Marvel-Kinofilm auftraten. Zählt man die Wolverine-Filme und *Deadpool* hinzu, gibt es bislang zehn X-Men-Kinofilme – weitere werden folgen!

Hätte man Stan Lee und seinen Kollegen 1963 oder 1970 oder sogar 1975 gesagt, dass die X-Men eines Tages Marvels erfolgreichste Heldenfamilie sein würden, dann hätte man sich bald einen Raum mit Zeitgenossen geteilt, die sich allesamt für Napoleon halten.

Doch durch Mutationen, so scheint es, ist *alles* möglich. Per Definition sind Mutanten die Zukunft – und nirgendwo mehr als in der wunderbaren Welt von Marvel!

– ROY THOMAS

GIANT-SIZE X-MEN No. 1
Page 10: *Interior, "Second Genesis"; script, Len Wein; pencils and inks, Dave Cockrum; May 1975.* The "second genesis" of X-Men who made their *Giant-Size* debut in 1975 included Storm (from Kenya), Thunderbolt (Apache Indian), Colossus (Soviet Union), and Nightcrawler (Germany). Joining them were previously premiered mutants Wolverine (Canada), Sunfire (Japan), and Banshee (Ireland).

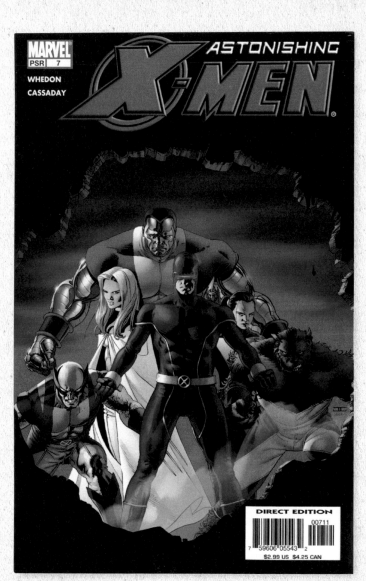

MAIS QU'EST-CE QU'ILS ONT DE SI SPÉCIAL, FINALEMENT, CES X-MEN ?

Pendant les vingt premières années d'existence des X-Men, pas sûr que les lecteurs de comics Marvel auraient trouvé très pertinent le titre de cette page. Non que la qualité du concept, né en 1963, laissât à désirer. Il avait même tout pour lui, à commencer par des auteurs d'exception : Stan Lee au scénario, Jack Kirby au dessin (et aussi, officieusement, à l'élaboration des intrigues). Autrement dit, le tandem qui venait de faire de *Fantastic Four* un extraordinaire succès.

Les X-Men présentent alors également l'avantage de combiner certaines propriétés des Quatre Fantastiques et de Spider-Man : ils forment une équipe de héros en uniforme et ont à peu près le même âge que Peter Parker. Leur commune origine sort elle aussi de l'ordinaire puisque tous sont des *mutants*, descendants de savants ayant vingt ans plus tôt participé au Projet Manhattan, le programme secret qui a donné naissance à la bombe atomique. (Théoriquement, certes, le Professeur Xavier accuse quelques années de trop pour partager semblable filiation, mais bon...) Dans cet univers Marvel tout juste émergent, il est déjà acquis qu'une fois exposé à la radioactivité – rayonnement cosmique, rayons gamma ou simple morsure d'une araignée momentanément irradiée – on se métamorphose en superhéros ! Ou comme ici, en un quintette superhéroïque.

Nanti de ces atouts, le magazine va rencontrer un succès honorable. D'aventure en aventure, les X-Men s'évertuent à rallier à leur cause les « bons mutants » et à pourchasser les vilains dont il faut faire cesser au plus vite les funestes agissements. Les gentils ont pour chef le Professeur Xavier, et les méchants son ennemi juré Magnéto, leader de la bien nommée Confrérie des Mauvais Mutants. Voilà de quoi se composera peu ou prou le quotidien des X-Men au cours de leurs

premières années, dont on retiendra surtout l'histoire des Sentinelles, ces robots géants programmés pour capturer tous les mutants au prétexte de leur différence – et les gens différents, c'est bien connu, on ne peut pas leur faire confiance. Les lecteurs commencent à goûter au symbolisme de la série...

Vers la fin de sa première vie, qui s'étendra tout de même sur soixante-six numéros, le dessinateur prodige Neal Adams et l'auteur de ces lignes viendront donner au titre un petit coup de jeune. Ce sera cependant à la fois trop peu et trop tard, et sa parution s'arrêtera net. Dès lors, les X-Men sembleront condamnés à se voir reléguer au statut d'occasionnelles *guest stars*, consolées çà et là par quelques séries dédiées à l'un ou l'autre de leurs membres. Et puis la fortune voudra bien leur sourire enfin – ainsi qu'à leurs fans. En 1974, lors d'une réunion rassemblant Stan Lee et quelques auteurs maison, quelqu'un proposera la création d'une équipe de superhéros issus de plusieurs pays différents, en l'occurrence des marchés à fort potentiel commercial pour la bande dessinée. Sur ma suggestion, le retour des X-Men sera acté, qui mettra en scène deux des mutants initiaux et des nouveaux venus aux nationalités diverses. Le revival démarrera un an plus tard, scénarisé par Len Wein (bientôt suivi de Chris Claremont, qui restera longtemps en place) et dessiné par Dave Cockrum, auquel succédera John Byrne. Revigoré, le magazine va alors entamer une ascension météorique. En cours de vol, néanmoins, l'idée d'associer les nouveaux mutants à des pays amateurs de comics sera abandonnée ; il est vrai que le débutant Colossus vient d'URSS et Tornade, qui détient le pouvoir de contrôler les éléments, est kényane. La superstar du magazine, évidemment, c'est Wolverine, l'équarrisseur canadien, mais les deux décennies suivantes accueilleront d'autres astres, tels Phénix (deux pour le prix d'une), Mystique, Malicia, Deadpool, Cable, Bishop ou Gambit. Les titres *X-Men* vont alors essaimer, se ramifier, croître et se multiplier. *Uncanny X-Men*, *New Mutants*, *X-Factor*, *Excalibur*, *X-Force*, *Generation X*, *Exiles* : il suffira d'un X pour être sûr qu'on est bien chez Marvel et qu'il y est question de mutants.

Les X-Men des années 1980, du reste, iront jusqu'à faire vaciller le trône du grand Spider-Man. Le concept finira même par devenir si populaire que ce seront les X-Men, et non Spider-Man, qui tiendront la vedette du premier vrai film de superhéros Marvel, en 2000. Si l'on recense les productions consacrées à Wolverine ainsi que *Deadpool*, on arrive à dix films X-Men à ce jour – et il s'en prépare encore beaucoup d'autres. Si l'on avait dit à Stan Lee et à ses acolytes, en 1963 (ou en 1970, voire en 1975), que *X-Men* deviendrait l'un des produits-phares de la Maison des Idées, on aurait été expédiés dare-dare en chambre capitonnée avec pour compagnons de sympathiques zigotos convaincus d'être Napoléon. Mais quand il y a mutation, tout peut arriver, la preuve. Et un mutant, par définition, ça montre le chemin. Chez Marvel Comics, c'est encore plus vrai qu'ailleurs.

– ROY THOMAS

ASTONISHING X-MEN No. 7

Page 14: *Cover; pencils and inks, John Cassaday; colors, Laura Martin; January 2005.* Marvel recruited A-list movie and TV talent Joss Whedon (*Buffy the Vampire Slayer*) in 2004 to scribe the new flagship X-Men title, *Astonishing X-Men*, with art by superstar John Cassaday.

X-MEN HIT THE BIG SCREEN

Following spread: *Movie still, X-Men, 20th Century Fox, 2000.* The X-Men debuted on film 37 years after their comic book first showed up on newsstands, with generations of fans turning out to make it a box office smash. The film featured Lee and Kirby–era Professor X (Patrick Stewart), Cyclops (James Marsden), and Marvel Girl (Famke Jansen), along with "All-New, All-Different"–era phenoms Storm (Halle Berry) and Wolverine (Hugh Jackman).

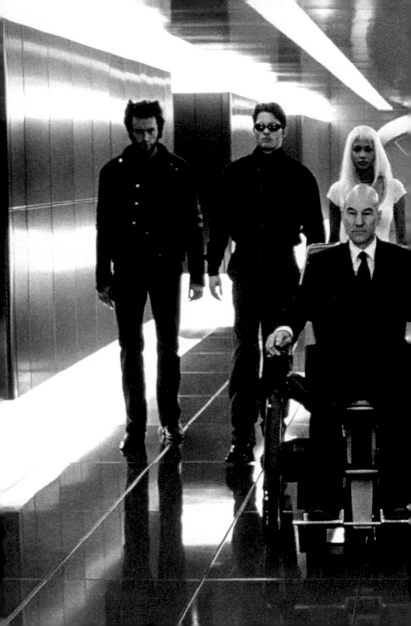

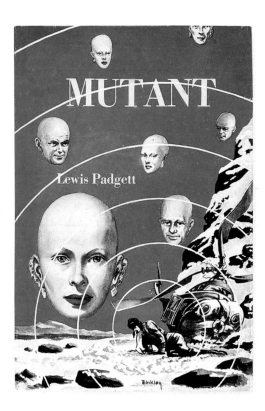

THE RISE OF THE MUTANT

Above: *Book cover; art, Ric Binkley; Gnome Press; 1953*. The word *mutant* gained popularity in mid-'50s science fiction. This 1953 Gnome Press collection of stories by Lewis Padgett (the joint pseudonym of husband/wife team Henry Kuttner and C.L. Moore) used the word as its title.

STRANGE TALES No. 31

Opposite: *Interior, "The Strange Ones"; script, unknown; pencils, Art Peddy; inks, attributed Bernie Sachs; August 1954*. The plot of this grim story roughly parallels the origin of Marvel's X-Men. Scientists (including a bald one) race around the world searching for "special" individuals to place into the service of humanity. Did Stan Lee remember this story when he and Jack Kirby plotted out X-Men? We'll probably never know.

THE STRANGE ONES!

IN ALL THE WORLD THERE WERE ONLY THREE OF THEM, A BOY AND TWO MEN... MUTANTS, THE NEXT ADVANCED LINK IN THE CHAIN OF MAN'S EVOLUTION! WITHIN THESE THREE STRANGE PEOPLE LURKED AWESOME POWERS...POWERS THAT COULD SAVE THE WORLD!

IN NEW MEXICO, A MAN DEEP IN THOUGHT STEPPED OFF A CURB! A CAR TRAVELING AT TREMENDOUS SPEED RACED AROUND THE CORNER...

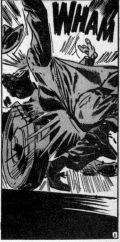

WHAM

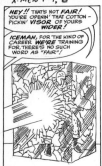

HEY!! THAT'S NOT *FAIR!* YOU'RE OPENIN' THAT COTTON-PICKIN' *VISOR* OF YOURS *WIDER!*

ICEMAN, FOR THE KIND OF CAREER *WE'RE* TRAINING FOR, THERE'S NO SUCH WORD AS "FAIR"!

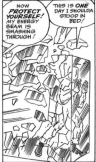

NOW *PROTECT* YOURSELF! MY ENERGY BEAM IS SMASHING THROUGH!

THIS IS *ONE* DAY I SHOULDA STOOD IN BED!

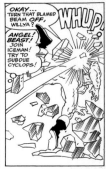

OKAY... TURN THAT BLAMED BEAM *OFF,* WILLYA?

WHUP!

ANGEL! BEAST! JOIN ICEMAN! TRY TO SUBDUE CYCLOPS!

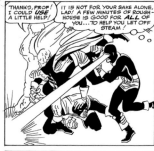

THANKS, PROF! I COULD *USE* A LITTLE HELP!

IT IS NOT FOR YOUR SAKE ALONE, LAD! A FEW MINUTES OF ROUGH-HOUSE IS GOOD FOR *ALL* OF YOU...TO HELP YOU LET OFF STEAM!

THEN, SUDDENLY, MINUTES LATER, A SHARP COMMANDING 'THOUGHT PIERCES THE BRAIN OF EACH OF THE FOUR RAMPAGING YOUTHS...

ENOUGH! THE LESSON IS OVER! WE MUST TURN OUR ENERGIES TO *DIFFERENT* MATTERS! RETURN TO YOUR PLACES... AT *ONCE!!*

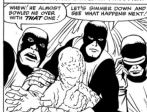

STUNNED BY THE FORCE AND EXPLOSIVE POWER OF *PROFESSOR XAVIER'S* MENTAL COMMAND, THE *X-MEN* RECOIL AND DRAW BACK, THEIR FRIENDLY FREE-FOR-ALL COMPLETELY FORGOTTEN!

WHEW! HE ALMOST BOWLED ME OVER WITH *THAT* ONE!

LET'S SIMMER DOWN AND SEE WHAT HAPPENS NEXT!

I CONGRATULATE YOU ALL! YOU HAVE MASTERED READING MY THOUGHTS PERFECTLY! AND NOW I SHALL RETURN TO NORMAL SPEECH COMMUNICATION!

YOU MAY BE INTERESTED TO LEARN THAT AT THIS VERY MOMENT I SENSE A TAXI APPROACHING OUR MAIN GATE! WITHIN THAT VEHICLE IS A NEW PUPIL...A MOST ATTRACTIVE *YOUNG LADY!*

7.

8.

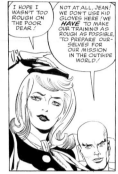

I HOPE I WASN'T TOO ROUGH ON THE POOR DEAR!

NOT AT ALL, JEAN! WE DON'T USE KID GLOVES HERE! WE *HAVE* TO MAKE OUR TRAINING AS ROUGH AS POSSIBLE, TO PREPARE OUR-SELVES FOR OUR MISSION IN THE OUTSIDE WORLD!

THAT'S WHAT I'VE WANTED TO ASK! JUST WHAT EXACTLY *IS* OUR REAL MISSION, SIR?

JEAN, THERE ARE MANY MUTANTS WALK-ING THE EARTH... AND *MORE* ARE BORN EACH YEAR!

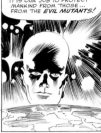

NOT *ALL* OF THEM WANT TO *HELP* MANKIND!... SOME *HATE* THE HUMAN RACE, AND WISH TO *DESTROY* IT! SOME FEEL THAT THE *MUTANTS* SHOULD BE THE REAL RULERS OF EARTH! IT IS OUR JOB TO PROTECT MANKIND FROM THOSE... FROM THE *EVIL MUTANTS!*

AT THAT VERY MOMENT, JUST SUCH A MUTANT PREPARES TO *STRIKE*... IN A SECRET LABORA-TORY NEAR CAPE CITADEL!

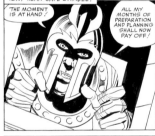

THE MOMENT IS AT HAND!

ALL MY MONTHS OF PREPARATION AND PLANNING SHALL NOW PAY OFF!

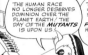

THE HUMAN RACE NO LONGER DESERVES DOMINION OVER THE PLANET EARTH! THE DAY OF THE *MUTANTS* IS UPON US!

THE FIRST PHASE OF MY PLAN SHALL BE TO SHOW MY *POWER*...TO MAKE HOMO SAPIENS BOW TO HOMO *SUPERIOR!*

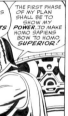

9/4 Deep

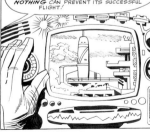

THE MIGHTIEST ROCKET OF ALL IS ABOUT TO BE LAUNCHED! USING MAXIMUM SECURITY PRECAUTIONS, THE GOVERNMENT FEELS *NOTHING* CAN PREVENT ITS SUCCESSFUL FLIGHT!

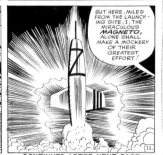

BUT HERE, MILES FROM THE LAUNCH-ING SITE I, THE MIRACULOUS *MAGNETO,* ALONE SHALL MAKE A MOCKERY OF THEIR GREATEST EFFORT!

11

CONTINUED AFTER NEXT PAGE...

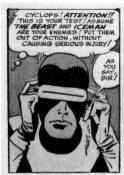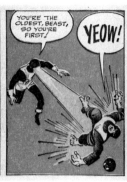

HOMO SUPERIOR

Previous spread: *Original interior art, "X-Men," X-Men No.1; script, Stan Lee; pencils, Jack Kirby; inks, Paul Reinman; September 1963.* The Marvel Age, still in its infancy, set a new record for most new super heroes introduced in a single issue: six! Xavier's old friend, the X-Men's nemesis Magneto, also debuts.

X-MEN No. 1

Above: *Interior, "X-Men"; script, Stan Lee; pencils, Jack Kirby; inks, Paul Reinman; September 1963.* Cyclops shows his great power, which will soon become his biggest fear: He has the power to accidentally injure someone close to him!

X-MEN No. 2

Opposite: *Interior, "No One Can Stop the Vanisher"; script, Stan Lee; pencils, Jack Kirby; inks, Paul Reinman; November 1963.* The X-Men are a group of five teenage mutants who live in Westchester, New York. They are led by an older, wheelchair-bound professor, and they call themselves Homo Superior. They are Cyclops (Scott Summers), who has incredibly powerful energy beams streaming constantly from his eyes; Marvel Girl (Jean Grey), who has the power of telekinesis; the Beast (Hank McCoy), who has great strength and even greater agility; the Angel (Warren Worthington III), who has wings and can fly; and the Iceman (Bobby Drake), who has the power to create cold.

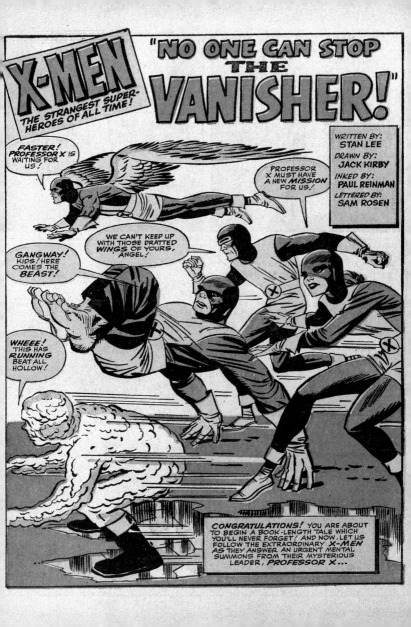

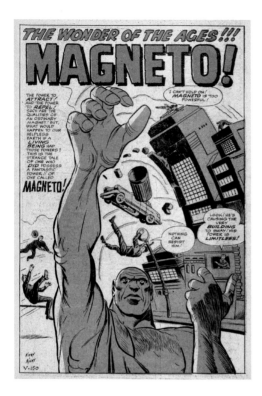

STRANGE TALES No. 84
Above: *Interior, "The Wonder of the Ages!!! Magneto!"; plot, Stan Lee; script, Larry Lieber; pencils, Jack Kirby; inks, Dick Ayers; May 1961.* The X-Men's super-nemesis wasn't Stan and Jack's first go-around with the code name Magneto. The Atlas monster comics of the '50s were rife with dormant names that would be recycled when the Marvel Age took flight.

X-MEN No. 4
Opposite: *Cover; pencils, Jack Kirby; inks, Paul Reinman; March 1964.* Gaining two new villains (the Scarlet Witch and Quicksilver), the X-Men follow in the Marvel tradition of having an evil team with a makeup similar to their own. The Brotherhood of Evil Mutants has five members, one of whom is female—just like the X-Men.

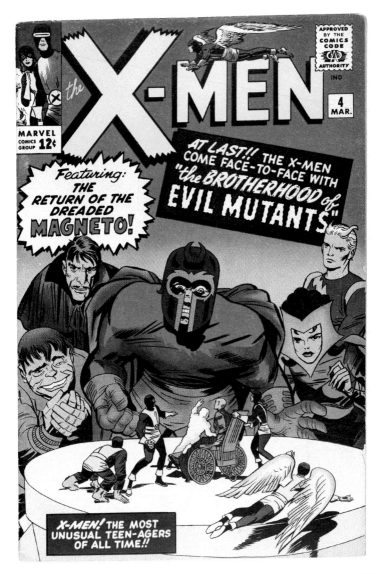

I **SHALL** WORRY--AS LONG AS WE MUST SERVE MAGNETO! BUT HEAR THIS, EVIL ONES-- IF ANY HARM EVER COMES TO MY SISTER--YOU SHALL ALL ANSWER TO **QUICKSILVER!**

I HAVE PLEDGED THAT **NONE** SHALL BE HARMED, SO LONG AS YOU OBEY ME IMPLICITLY! AND NOW, ENOUGH OF THIS **CHARADE!** THERE IS **WORK** TO BE DONE!

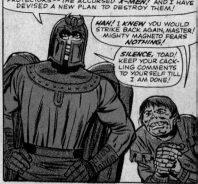

REMEMBER, BEFORE WE CAN FIND A WAY TO CONQUER AND RULE THE INFERIOR **HUMANS** WHO INHABIT OUR PLANET, WE MUST FIRST DEFEAT THEIR SELF-STYLED PROTECTORS--THE ACCURSED **X-MEN!** AND I HAVE DEVISED A NEW PLAN TO DESTROY THEM!

HAH! I **KNEW** YOU WOULD STRIKE BACK AGAIN, MASTER! MIGHTY MAGNETO FEARS **NOTHING!**

SILENCE, TOAD! KEEP YOUR CACKLING COMMENTS TO YOURSELF TILL I AM DONE!

WHILE BACK AT THE X-MEN'S SECRET SCHOOL...

SCOTT, WOULD YOU ACCOMPANY ME TO THE WEST WING?

CERTAINLY, SIR!

STRANGE! THIS IS THE ONE SECTION THAT HAD BEEN "OFF-LIMITS" TO US!

I IMAGINE THAT YOU HAVE LONG WONDERED WHAT IS **KEPT** IN THIS DARKENED, LOCKED SECTION OF THE SCHOOL!

YES SIR! WE HAVE ALL BEEN CURIOUS ABOUT IT FOR MONTHS!

THEN, AFTER THE LIGHTS ARE TURNED ON...

GOSH! WHAT **IS** ALL THAT??

SOMETHING I'VE BEEN WORKING ON FOR A LONG LONG TIME! YOU ARE THE ONLY OTHER PERSON WHO WILL SHARE MY SECRET!

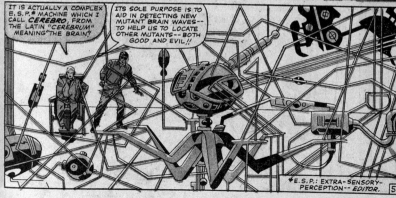

IT IS ACTUALLY A COMPLEX E.S.P.* MACHINE WHICH I CALL **CEREBRO,** FROM THE LATIN "CEREBRUM" MEANING "THE BRAIN"

ITS SOLE PURPOSE IS TO AID IN DETECTING NEW MUTANT BRAIN WAVES-- TO HELP US TO LOCATE OTHER MUTANTS--BOTH GOOD AND EVIL!!

*E.S.P.: EXTRA-SENSORY-PERCEPTION-- EDITOR.

5

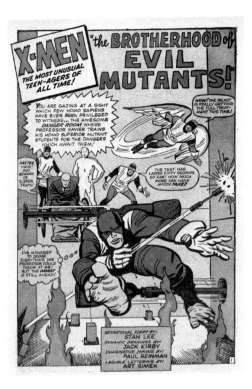

X-MEN No. 7

Opposite: *Interior, "The Return of the Blob!"; script, Stan Lee; pencils, Jack Kirby; inks, Chic Stone; September 1964*. Lee and Kirby's *X-Men* delves into sci-fi with Cerebro, the mutant tracking machine that uses Xavier's brainwaves to pluck signals of mutant presence out of the ether, the better to liberate or protect them, or in the case of evil mutants—fight them!

X-MEN No. 4

Above: *Interior, "The Brotherhood of Evil Mutants!"; script, Stan Lee; pencils, Jack Kirby; inks, Paul Reinman; March 1964*. Welcome to the Danger Room, a controlled environment where young and inexperienced mutants must train to harness their powers. According to Stan Lee, the battle simulation gym was a Kirby concept: "I thought it was great because we could always open with an action sequence if we needed to."

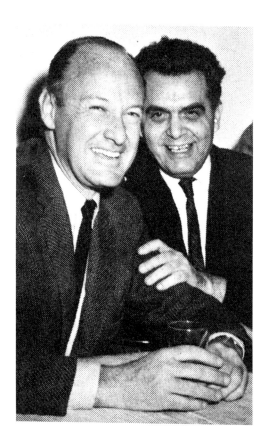

THE MAN AND THE KING

Above: *Photograph, Stan Lee and Jack Kirby, 1966.*

X-MEN No. 8

Opposite: *Cover; pencils, Jack Kirby; inks, Chic Stone; November 1964.* Stan Lee had early on established a trope in his Marvel Age storytelling: members of a super hero group threatening to leave the team. In *X-Men* No. 6, the Beast quits the team, only to rejoin when his former teammates face the menace of Unus, a mutant who is pushed by Magneto to fight the X-Men.

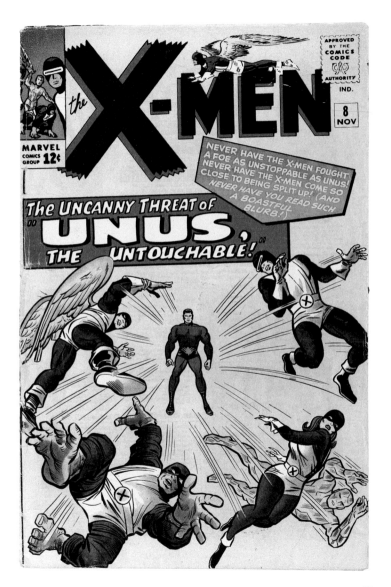

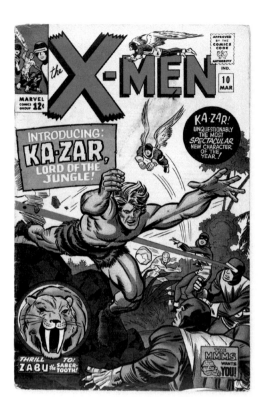

X-MEN No. 10

Above: *Cover; pencils, Jack Kirby; inks, Chic Stone; March 1965.*
In the Savage Land, the X-Men discovered a secret world
of dinosaurs, tribal warfare, and Ka-Zar, a name Stan Lee
borrowed from Timely's stable of pulp heroes.

X-MEN No. 9

Opposite: *Cover; pencils, Jack Kirby; inks, Chic Stone; January
1965.* Stan Lee and Jack Kirby wasted no time integrating
their mysterious mutants into the wider Marvel Universe. Of
special note: Future Avengers mainstays Scarlet Witch and
Quicksilver did not appear in this battle; they were still members
of Magneto's Brotherhood of Evil Mutants, you see!

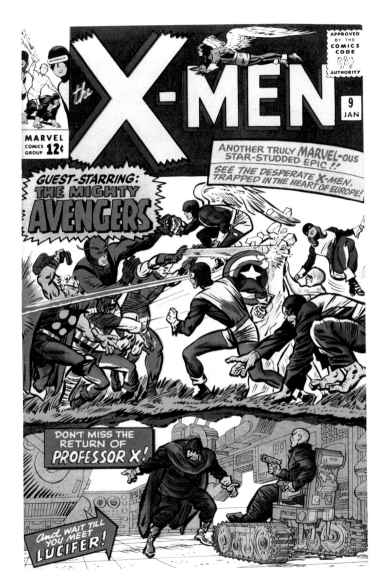

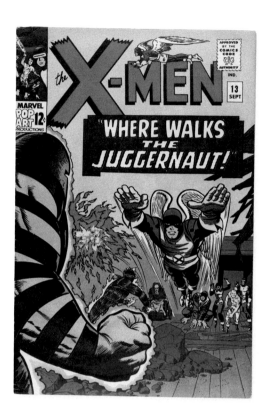

X-MEN No. 13

Above and opposite: *Cover; pencils, Jack Kirby; inks, Joe Sinnott. Interior, "Where Walks the Juggernaut!"; script, Stan Lee; pencils, Kirby and Werner Roth; inks, Sinnott. September 1965.* Stan Lee and Jack Kirby reinforced the intimacy in the interconnectedness of the lives of mutants by giving Xavier and Magneto a shared backstory as friends. They returned to that notion again with Juggernaut: As Xavier's hostile half-brother, Cain Marko's brutal visage and unstoppable momentum made him a true force to be reckoned with.

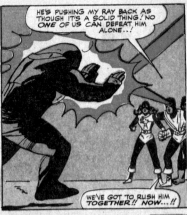

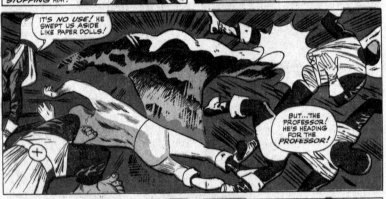

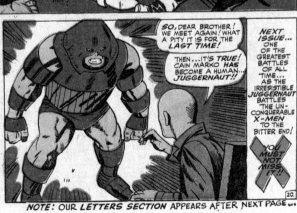

NOTE: OUR *LETTERS* SECTION APPEARS AFTER NEXT PAGE ..

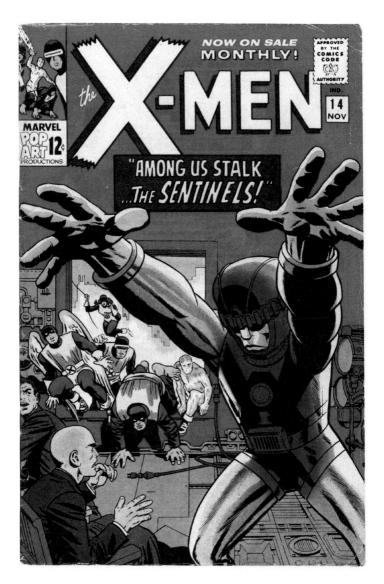

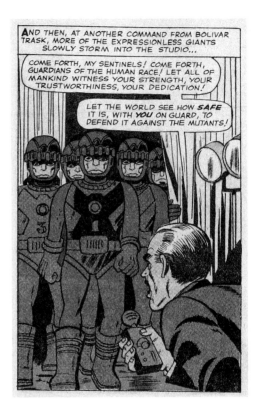

X-MEN No. 14

Opposite and above: *Cover: pencils, Jack Kirby; inks, Wally Wood; November 1965. Interior, "Among Us Stalk the Sentinels!": script, Stan Lee; layouts, Jack Kirby; finished pencils, Werner Roth; inks, Dick Ayers. January 1966.* Dr. Bolivar Trask convinces the public that mutants are a menace. His Sentinels, a legion of robots with cybernetic brains, shake Trask's control and confront the X-Men.

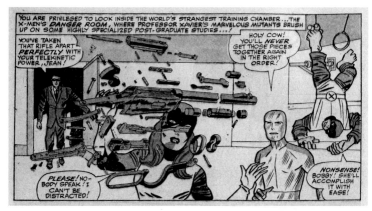

X-MEN No. 10

Top: *Interior, "The Coming of…Ka-Zar!"; script, Stan Lee; pencils, Jack Kirby; inks, Chic Stone; January 1965.* World War II combat veteran Jack Kirby was surely acquainted with rifle schematics, and adeptly translated his experience to Marvel Girl's thrilling usage of her telekinetic powers.

EXPLODED VIEWPOINT

Above: *Diagram from rifle manual, Civilian Marksmanship Program, date unknown.*

X-MEN No. 28

Opposite: *Cover; pencils, Werner Roth; inks, John Tartaglione; January 1967.* Artist Werner Roth, who tended toward a naturalistic style, was pushed at Marvel to design bolder and more dramatic covers and situations.

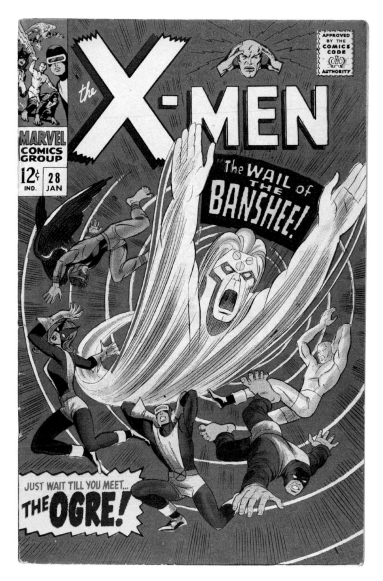

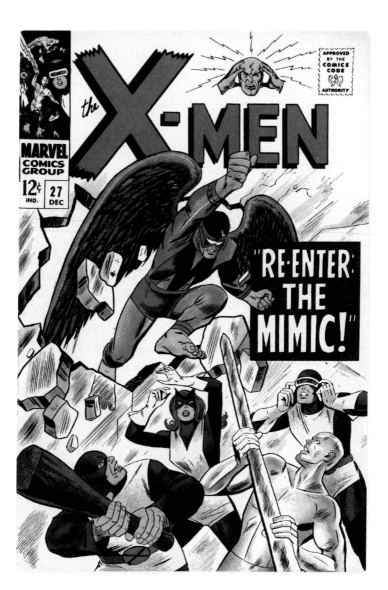

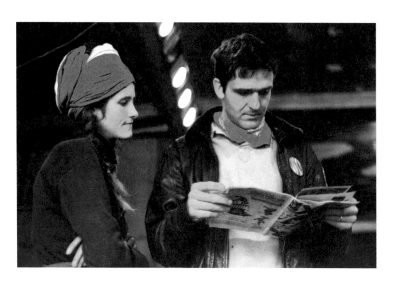

X-MEN No. 27

Opposite: *Cover; layouts, Jack Kirby; pencils, Werner Roth; inks, John Tartaglione; December 1966.* Calvin Rankin, aka the Mimic, was the first new member of the X-Men to join the original five. Mimic's powers were hinted at by his name: He was able to adopt the super-powered abilities of those near him. His tenure, however, was short-lived, as the irascible Mimic lost his powers and left the team.

MERRY PRANKSTERS AND MUTANT MISFITS

Above: *Photograph, Ted Streshinsky,* New York: The World Journal Tribune Magazine, *1966.* Ken Kesey's Merry Pranksters, at the epicenter of nonconformist '60s counterculture, counted among their membership *X-Men* fans Mountain Girl and Ken Babbs, who are seen here enjoying the story in *X-Men* No. 27. (With a name like Mountain Girl, are we sure the future Mrs. Jerry Garcia wasn't an X-Man herself?)

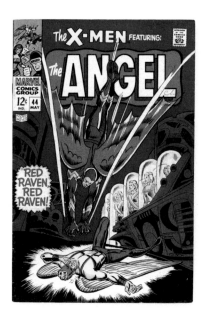

X-MEN No. 44

Above: *Cover: pencils, Don Heck; inks, John Tartaglione; May 1968.* Roy Thomas brings back an obscure character from the Golden Age, Red Raven.

UNPUBLISHED COVER

Opposite: *Original cover art; pencils and inks, Dan Adkins; November 1967.* Stan Lee was a stickler for cover layouts, so artist Dan Adkins had to take this design for *X-Men* No. 38 back to the drawing board. In the final layout, the Blob's arms were wrapped completely around a more upright Angel, and all the figures were pulled a bit closer to the foreground, opening up more room for Beast, Marvel Girl, and even the Vanisher to be more visible.

COMICS ACCORDING TO ESQUIRE

Following spread: Esquire, *"As Barry Jenkins, Ohio '60, Says: 'A Person Has to Have Intelligence to Read Them,'" September 1965. Esquire* poked a little fun at the idea of college kids elevating comics to the realm of literature. In a goofy spread that quotes eight students about their appreciation of comics, Ohio undergrad Barry Jenkins flies aloft the wings of the Angel.

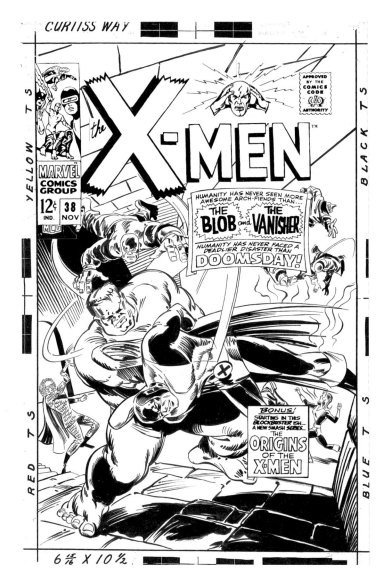

43

As Barry Jenkins, Ohio '69, Says: "A Person Has to Have Intelligence to Read Them"

Eight honest-to-God exegeses of Marvel Comics from Institutions of Higher Learning across the land

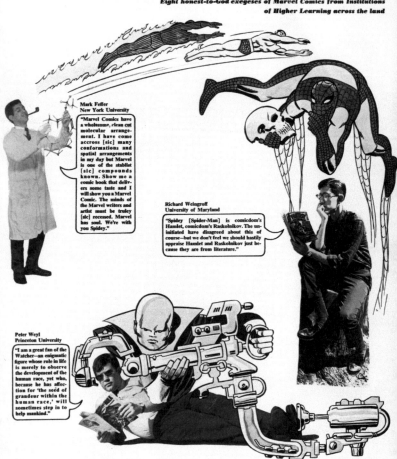

Mark Feffer
New York University

"Marvel Comics have a wholesome, clean cut molecular arrangement. I have come accross [sic] many conformations and spatial arrangements in my day but Marvel is one of the stablist [sic] compounds known. Show me a comic book that delivers some taste and I will show you a Marvel Comic. The minds of the Marvel writers and artist must be truley [sic] recessed. Marvel has soul. We're with you Spidey."

Richard Weingroff
University of Maryland

"Spidey [Spider-Man] is comicdom's Hamlet, comicdom's Raskolnikov. The uninitiated have disagreed about this of course—but we don't feel we should hastily appraise Hamlet and Raskolnikov just because they are from literature."

Peter Weyl
Princeton University

"I am a great fan of the Watcher—an enigmatic figure whose role in life is merely to observe the development of the human race, yet who, because he has affection for 'the seed of grandeur within the human race,' will sometimes step in to help mankind."

Drawings by Jack Kirby

The Gimmick: Marvel's super-heroes, in spite of their super-powers, all have human problems. And that's why your college buddies are flipping over them. Spider-Man, in real life a college student named Peter Parker, is guilt-ridden, money-conscious, socially insecure, and gets blamed for things he didn't do. The Fantastic Four are always quarreling among themselves. Thor's father won't let him marry the girl he loves, and the Hulk is totally alienated. This, plus a tongue-in-cheek approach, which takes more than a third-grade education to appreciate, is Marvel's appeal. For example: in one issue, Spider-Man is desperately fighting the Looter as they both float high above the city suspended from a helium balloon. As the Looter tries to kick him in the face, Spidey asks, "Have you ever considered medical help because of your antisocial tendencies?" And then, "Why is it that everyone I fight is overflowing with neurotic hostility?" The Looter, hip to the absurdity of Spidey's chatter, counters with, "You must be mad—talking that way while you battle for your life!" Now, where else could you find stuff like that? Certainly not in your Brand Eechs comic books. Nosiree.

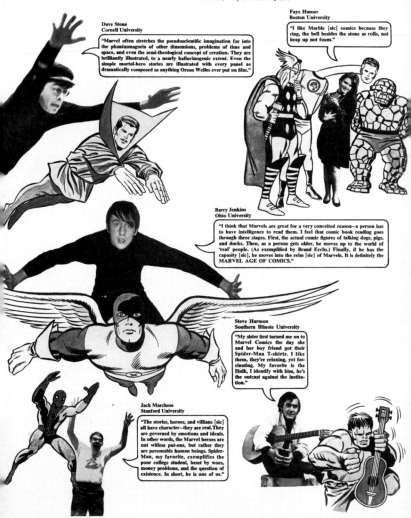

Dave Stone
Cornell University

"Marvel often stretches the pseudoscientific imagination far into the phantasmagoria of other dimensions, problems of time and space, and even the semi-theological concept of creation. They are brilliantly illustrated, to a nearly hallucinogenic extent. Even the simple mortal-hero stories are illustrated with every panel as dramatically composed as anything Orson Welles ever put on film."

Faye Hauser
Boston University

"I like Marble [sic] comics because they ring, the bell besides the stone as rolls, not heap up not foam."

Barry Jenkins
Ohio University

"I think that Marvels are great for a very conceited reason—a person has to have intelligence to read them. I feel that comic book reading goes through three stages. First, the actual comic figures of talking dogs, pigs, and ducks. Then, as a person gets older, he moves up to the world of 'real' people. (As exemplified by Brand Eechs.) Finally, if he has the capacity [sic], he moves into the relm [sic] of Marvels. It is definitely the **MARVEL AGE OF COMICS.**"

Steve Harmon
Southern Illinois University

"My sister first turned me on to Marvel Comics the day she and her boy friend got their Spider-Man T-shirts. I like them, they're relaxing, yet fascinating. My favorite is the Hulk, I identify with him, he's the outcast against the institution."

Jack Marchese
Stanford University

"The stories, heroes, and villians [sic] all have character—they are real. They are governed by emotions and ideals. In other words, the Marvel heroes are not witless put-ons, but rather they are personable human beings. Spider-Man, my favorite, exemplifies the poor college student, beset by woes, money problems, and the question of existence. In short, he is one of us."

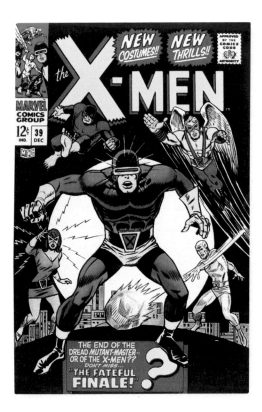

X-MEN No. 39

Above: *Cover: pencils and inks, George Tuska; December 1967.* On a break from defending mutantkind from menace, Jean Grey designed dramatic new duds for her X-Men mates. Her green mini-skirt ensemble was the eye-popping winner of the group, while Angel's red-and-yellow tights with suspenders proved not quite ready for the runway.

X-MEN No. 46

Opposite: *Cover: pencils and inks, Don Heck; July 1968.* Would you believe it really *was* the end of the X-Men? Well, for a few issues anyway. With sales slipping somewhat, Stan Lee and company decided to try to amp up reader interest by focusing on solo adventures of the fragmented group.

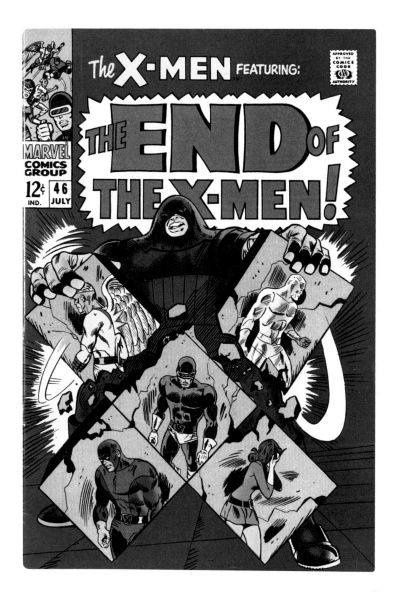

47

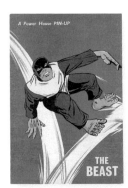
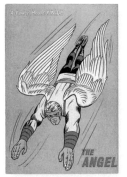
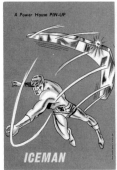
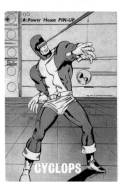

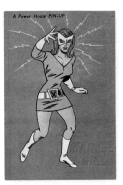

POWER PINUPS

Above: *Pinup art, Barry Windsor-Smith, ca. 1968.* A very young Barry Windsor-Smith illustrated pinups that were featured on the backs of the Power Comics line of reprints. These pages were among his first professional comics work.

FANTASTIC No. 38

Opposite: *Cover: pencils, Jack Kirby; inks, Dick Ayers; November 1967.* The weekly comic book *Fantastic*, published in the United Kingdom by Odhams Press under the Power Records imprint, brought the adventures of the X-Men (as well as Thor and Iron Man) into the hands of British kids, by reprinting the original American Marvel Comics—albeit in glorious black and white. This issue repurposed the cover from *X-Men* No. 20 (May 1966). *Fantastic* ran for a year and a half, beginning in February 1967.

FANTASTIC

4 NOVEMBER 1967 © Odhams Press Ltd., England 1967

A POWER COMIC

No. 38 EVERY MONDAY 9d.

AUSTRALIA 10c. EAST AFRICA 1.25 RHODESIA 1/3
SOUTH AFRICA 10c. NEW ZEALAND 1/- (10c.) WEST AFRICA 1/-

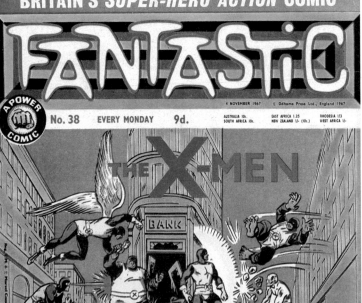

THE X-MEN

FEATURING: THE UNTOLD STORY OF HOW PROFESSOR X LOST THE USE OF HIS LEGS!

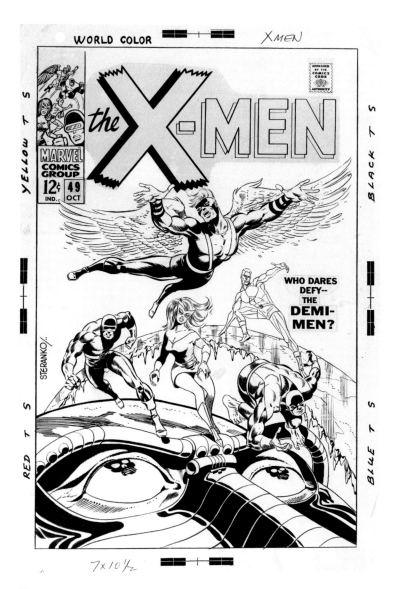

X-MEN No. 49

Opposite: *Original cover art; pencils and inks, Jim Steranko; October 1968.* Jim Steranko brought a sense of dynamism to this poster-like composition. He worked on *X-Men* only briefly, and then only as an artist. It would take the likes of Neal Adams working with Roy Thomas to begin to shake things up for the faltering title.

X-MEN No. 50

Above: *Interior, "City of Mutants!"; script, Arnold Drake; pencils, Jim Steranko; inks, John Tartaglione; November 1968.*

X-MEN No. 50

Following spread: *Interior, "City of Mutants"; script, Arnold Drake; pencils, Jim Steranko; inks, John Tartaglione; November 1968.* Jim Steranko delivered a pair of bang-up stories in keeping with the sleek and cutting edge work he'd delivered on the Nick Fury feature in *Strange Tales*. The low-selling *X-Men* seemed to be a home for breaking talent such as Steranko and, later, Barry Windsor-Smith and Neal Adams.

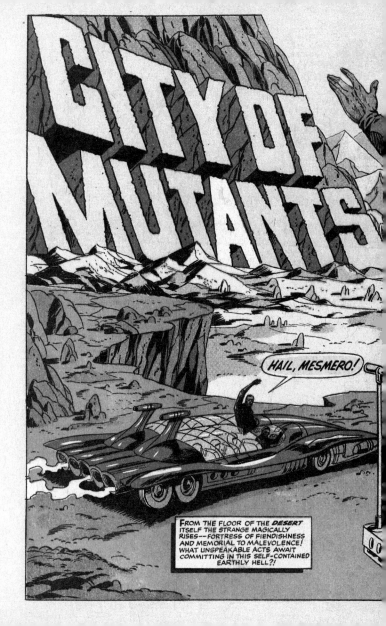

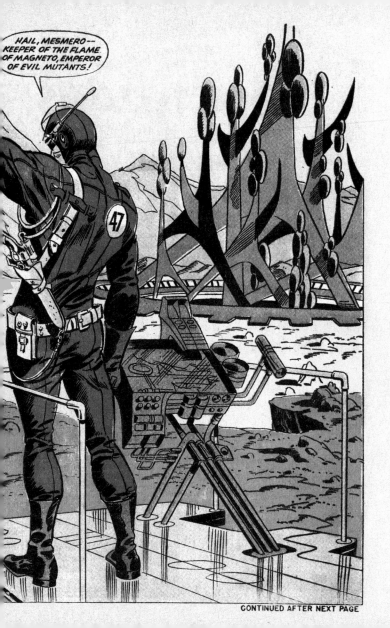

CONTINUED AFTER NEXT PAGE

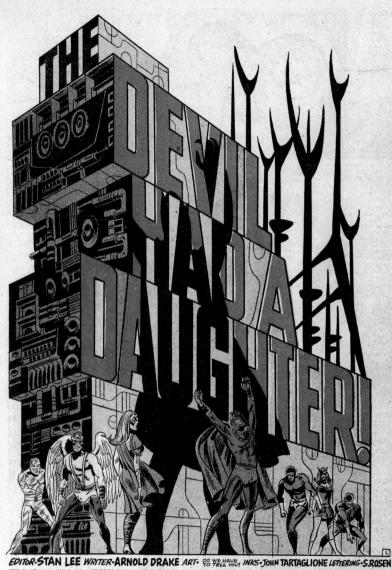

EDITOR•STAN LEE WRITER•ARNOLD DRAKE ART• DO WE HAVE TO TELL YOU? INKS•JOHN TARTAGLIONE LETTERING•S. ROSEN

THE X-MEN is published by PERFECT FILM & CHEMICAL CORP. OFFICE OF PUBLICATION: 625 MADISON AVENUE, NEW YORK, N.Y. 10022. SECOND CLASS POSTAGE PAID AT NEW YORK, N.Y. AND AT ADDITIONAL MAILING OFFICES. Published monthly. Copyright ©1968 by Perfect Film & Chemical Corp., Marvel Comics Group, all rights reserved, 625 Madison Avenue, New York, N. Y. 10022. Vol. 1, No. 51, December, 1968 issue. Price 12¢ per copy. No similarity between any of the names, characters, persons and/or institutions in this magazine with those of any living or dead person or institution is intended, and any such similarity which may exist is purely coincidental. Printed in the U.S.A. by World Color Press, Inc., Sparta, Illinois 62286. Subscription rate $1.75 and $2.25 Canada for 12 issues including postage. Foreign subscriptions $3.25.

X-MEN No. 51

Opposite: *Interior, "The Devil Had a Daughter!"; script, Arnold Drake; pencils, Jim Steranko; inks, John Tartaglione; December 1968.* Doom Patrol cocreator Arnold Drake scripted eight issues of *X-Men* before making way for Roy Thomas's return to the title. Despite his brief run, Drake cocreated the green-haired telekinetic Polaris, devised the idea of giving Scott Summers a mutant brother, and saw his stories the recipient of some stunning design work by Steranko.

NEW LOOK, NEW LOGO

Below: *Cover; pencils and inks, Jim Steranko; December 1968.* Steranko's short-lived tenure on *X-Men* had long-lasting implications for the book's design: His brand-new logo would last on the title for generations.

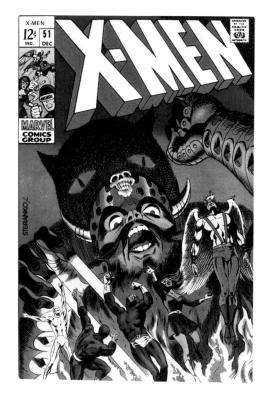

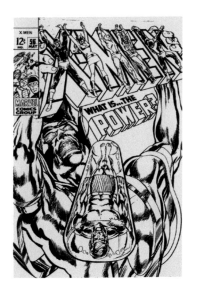
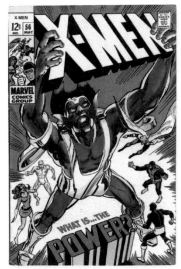

X-MEN No. 56

Above: *Final cover art and original cover art (unpublished); pencils, Neal Adams; inks, Tom Palmer; May 1969.* "I did this cover and handed it in. Stan took it to Martin Goodman and afterwards, Stan called me in, saying, I really have to reject the cover, but if it were up to me, I would say go with it but I'm told we can't do it because the figures obliterate the logo. I said 'Stan, when it's colored the figures aren't going to obliterate the logo.' He said, Well, it's just not acceptable. You'll have to do it over or I can get someone else to do it. I said 'No, no, Stan, I'll do it.' I thought, they're going to kill the book in two issues, and they're worried if anyone can identify the logo…?" — Neal Adams

X-MEN No. 59

Opposite: *Interior, "Do or Die, Baby!"; script, Roy Thomas; pencils, Neal Adams; inks, Tom Palmer; August 1969.* After a meeting with Marvel's young phenom, Jim Steranko, Adams decided to try out the Marvel approach, which brought him added freedom in storytelling. On this page the Scarlet Witch displays her power dramatically, and we see that a small comic book panel was not big enough!

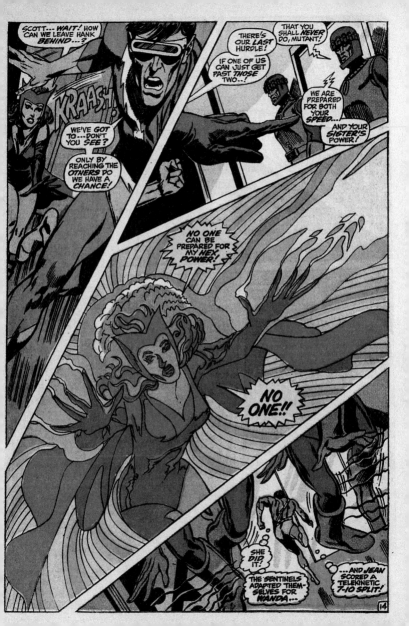

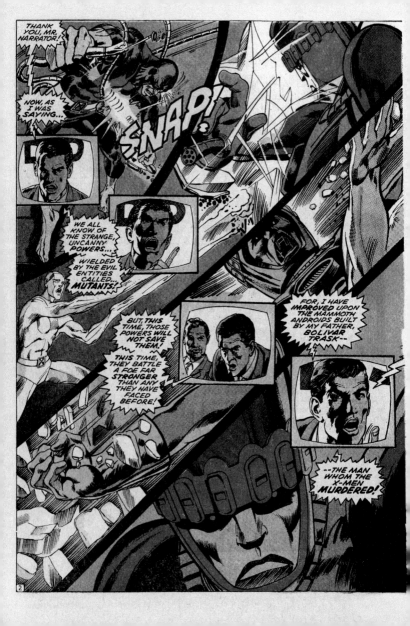

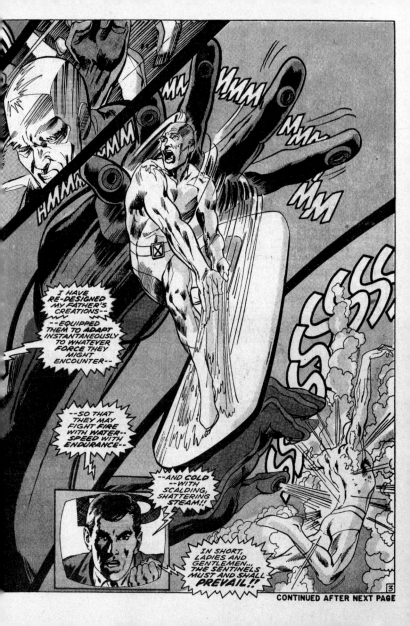

I HAVE RE-DESIGNED MY FATHER'S CREATIONS-- --EQUIPPED THEM TO ADAPT INSTANTANEOUSLY TO WHATEVER FORCE THEY MIGHT ENCOUNTER--

--SO THAT THEY MAY FIGHT FIRE WITH WATER-- SPEED WITH ENDURANCE--

--AND COLD --WITH SCALDING, SHATTERING STEAM!!

IN SHORT, LADIES AND GENTLEMEN... THE SENTINELS MUST AND SHALL PREVAIL!!

HMMM

MM MM

MM

MM

SSS SSSS

3

CONTINUED AFTER NEXT PAGE

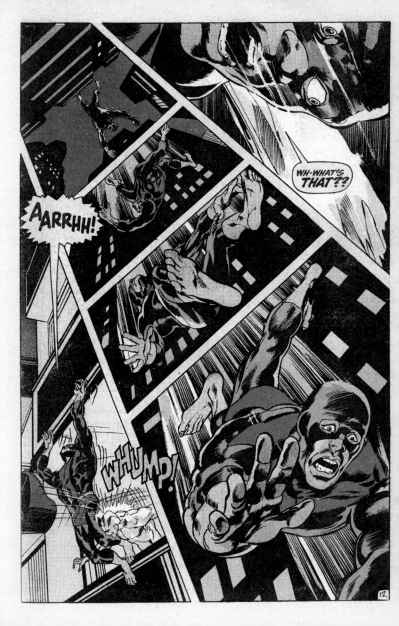

X-MEN No. 57

Previous spread and opposite: *Interior, "The Sentinels Live!";*
script, Roy Thomas; pencils, Neal Adams; inks, Tom Palmer; June
1969. Neal Adams was a young, innovative artist who made
a name for himself applying his more realistic, advertising
illustration–influenced style on DC's super hero books. On this
page Adams arranges panels to create movement as the Beast
falls. Thomas and Adams give the strip a very different look,
one not of this Earth, yet more realistic and familiar than ever.

THE RASCALLY ONE

Below: *Photograph, Roy Thomas, 1972.*

NEAL ADAMS

Below: *Photograph, Neal Adams, ca. late '60s.* A rising star at DC, *X-Men* was Neal Adams's first work for Marvel.

X-MEN No. 58

Opposite: *Cover; pencils, Neal Adams; inks, Tom Palmer; July 1969.* Here comes Havok! Scott Summers's long-lost brother Alex debuted a few issues earlier, but it was here that his powers would manifest and he would take the code name Havok.

NEAL ADAMS

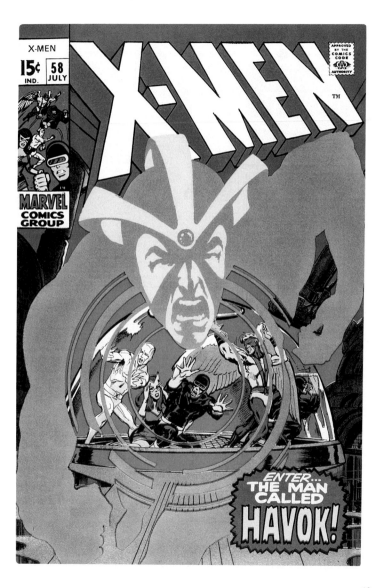

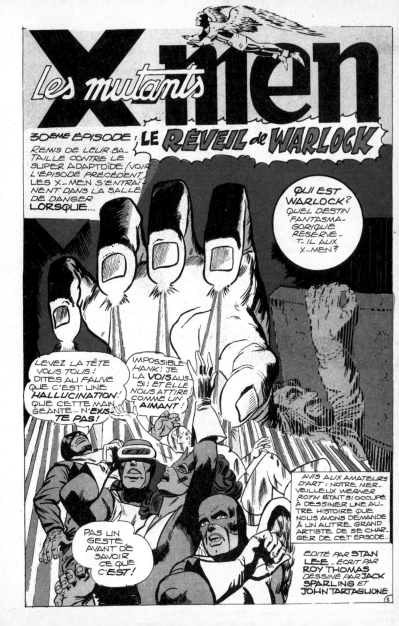

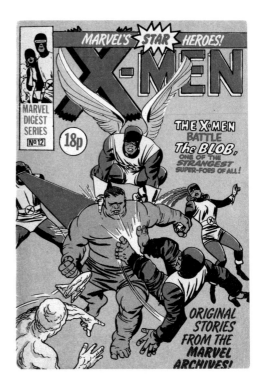

WHAT'S "MUTANT" IN FRENCH?

Opposite: *"Le reveil de Warlock"; script, Roy Thomas; pencils, Jack Sparling; inks, John Tartaglione; June 1972*. Publisher Editions LUG brought Marvel Comics to French readers in 80-plus-page reprint anthologies. *Strange* No. 30 collected *X-Men* No. 30, along with an issue each of *Daredevil*, *Iron Man*, and *Amazing Spider-Man*.

MARVEL DIGEST SERIES X-MEN No. 12

Above: *Cover; pencils, Jack Kirby; inks, Sol Brodsky; 1980*. Black-and-white *X-Men* reprints returned to British shelves— this time in handy pocket-book size—with the Marvel Digest Series line, launched in 1980 by then Marvel UK editorial director (and the U.K.'s answer to Stan Lee) Dez Skinn. Sharp-eyed fans will recognize the Kirby cover from *X-Men* No. 3 (January 1964).

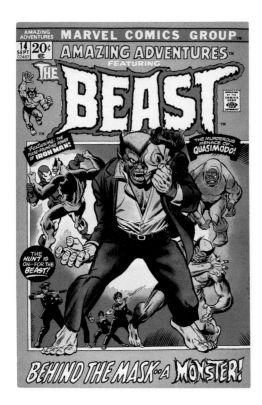

AMAZING ADVENTURES No. 14

Above: *Cover; pencils, Gil Kane; inks, Jim Mooney; September 1972.* While the *X-Men* title was in its reprint years doldrums (1971–1974, roughly), the Beast could be found starring in the *Amazing Adventures* anthology. The seven-issue series had the distinction of introducing Hank McCoy in the furry form that has been part of his identity ever since.

AMAZING ADVENTURES No. 15

Opposite: *Interior, "Murder in Mid-Air!"; script, Steve Englehart; pencils, Tom Sutton; inks, Frank Giacoia and John Tartaglione; November 1972.* Blue fur wasn't the only thing that made its debut in the new Beast series: it also introduced the Golden Age, red-headed, glamour girl Patsy Walker into the mainstream Marvel Universe.

OH *GOLLY!* IT-- IT'S THAT *BEAST-CREATURE* BUZZ HAS BEEN TRYING TO *CATCH*--

--BUT IT'S *WOUNDED!* IT MUST HAVE STAGGERED HERE JUST BEFORE *COLLAPSING!*

I'D BETTER TELEPHONE *BUZZ* AT HIS *OFFICE!*

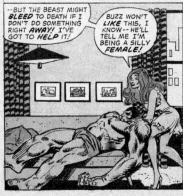

--BUT THE BEAST MIGHT *BLEED* TO DEATH IF I DON'T DO SOMETHING RIGHT *AWAY!* I'VE GOT TO *HELP* IT!

BUZZ WON'T *LIKE* THIS, I KNOW-- HE'LL TELL ME I'M BEING A SILLY *FEMALE!*

STILL, WHEN ANYTHING'S *LIFE* IS AT STAKE--!

"WHEN ANYTHING'S LIFE IS AT STAKE.."

"..LIFE IS AT STAKE..."

"...LIFE IS..."

"LIFE"

"LIFE"

"LIFE"

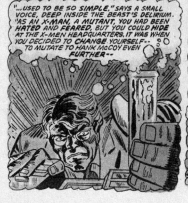

"...USED TO BE SO *SIMPLE*," SAYS A SMALL VOICE, DEEP INSIDE THE BEAST'S DELIRIUM. "AS AN X-MAN, A MUTANT, YOU HAD BEEN *HATED* AND *FEARED*, BUT YOU COULD *HIDE* AT THE X-MEN HEADQUARTERS. IT WAS WHEN YOU DECIDED TO *CHANGE* YOURSELF-- TO MUTATE TO HANK McCOY EVEN *FURTHER*--

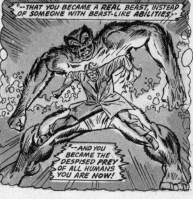

"--THAT YOU BECAME A *REAL BEAST*, INSTEAD OF SOMEONE WITH BEAST-LIKE *ABILITIES*--

"--AND YOU BECAME THE DESPISED *PREY* OF ALL HUMANS YOU ARE NOW!"

THE WOLVERINE IS BORN

Below: *Original character design; art, John Romita; 1974.* The best character designer in the business, "Jazzy Johnny" does it again with the single most significant super hero creation this side of the Silver Age. Though the kitty whiskers were soon dispensed with, Wolverine would in time establish himself as the best there is at what he does…and what he does is sell comic books. And cartoons. And Halloween costumes with plastic retractable claws. And movies. And even more comics.

THE INCREDIBLE HULK No. 181

Opposite: *Cover: pencils and inks, Herb Trimpe; November 1974.* The first full appearance of the figure who would become central to the comics' new direction. The first Bronze Age book to break the six-figure barrier, a copy graded 9.9 by the CGC (Certified Guaranty Company) sold for $150,000 in 2011!

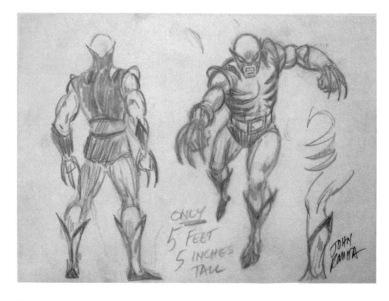

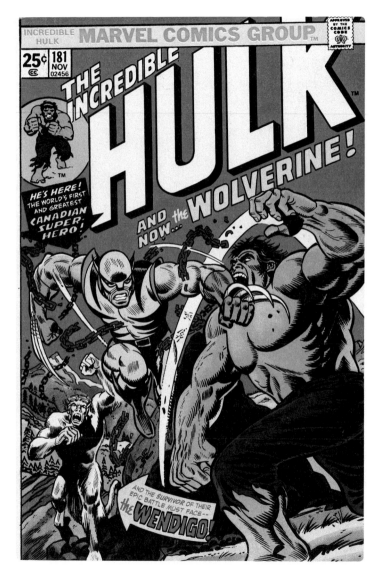

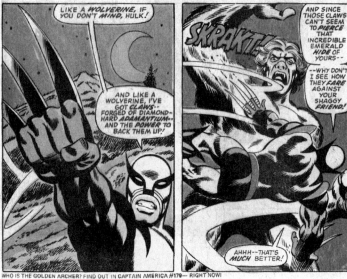

WHO IS THE GOLDEN ARCHER? FIND OUT IN CAPTAIN AMERICA #179— RIGHT NOW!

THE INCREDIBLE HULK No. 181

Above: *Interior, "And Now…the Wolverine!"; script, Len Wein; pencils, Herb Trimpe; inks, Jack Abel; November 1974.* "John [Romita Sr.]'s story was that Roy came to him and asked him to design a character called Wolverine…. And John said, 'I didn't even know what a wolverine was. I thought it was a female wolf. [So] I got out the encyclopedia.'" — Herb Trimpe

GIANT-SIZE X-MEN No. 1

Opposite: *Interior, "Second Genesis"; script, Len Wein; pencils and inks, Dave Cockrum; May 1975.* Only five months after the character's *Incredible Hulk* debut, Wolverine cocreator Len Wein jumped at the chance to include the feisty Canadian with claws into the newly reconstituted X-Men lineup. From the beginning, facts of Wolverine's mysterious past were only hinted at through bits and pieces of dialogue.

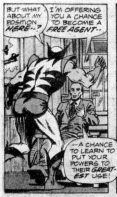

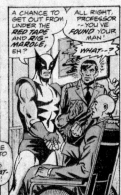

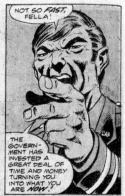

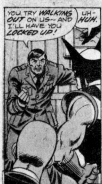

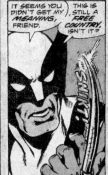

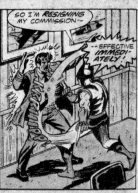

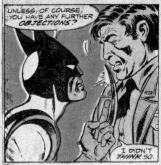

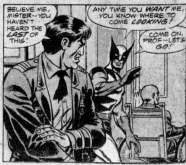

JACK RUSSELL MUST DESTROY THE DEATH-DEMON IN WEREWOLF BY NIGHT #30!

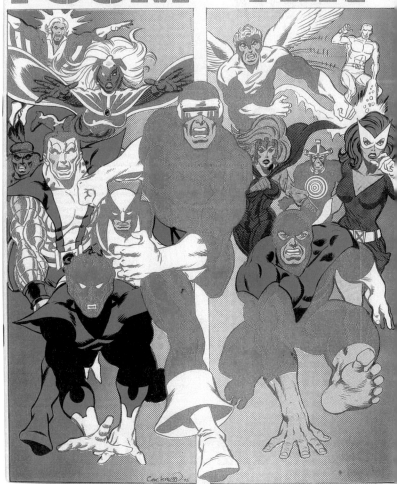

F. O. O. M. No. 10

Opposite: *Cover; pencils and inks, Dave Cockrum; June 1975.* In the months between the release of *Giant-Size X-Men* No. 1 and *X-Men* No. 94, Marvel house fanzine *F.O.O.M.* came out with an all-X-Men issue — so somebody in the office was excited about hyping the dark horse revival! Among the highlights of the enthusiastic coverage: an irreverent cartoon picturing Len Wein, Chris Claremont, and Dave Cockrum being burned at the stake by longtime X-Men fans for "destroying" the team they knew and loved.

X-MASTERMIND

Above: *Photographs, Eliot R. Brown; "Artist's artist" Dave Cockrum and Chris Claremont at the Marvel offices, ca. 1979.* If you dug the Marvel mutants' sense of style in the mid-1970s to early 1980s, you have Cockrum to thank. The talented sequential artist had a gift for character design. Meanwhile, Claremont became the regular *X-Men* writer in 1975, aged 24, and stayed with the title until the early 1990s. His complex but relatable ongoing adventure sagas and emotionally rich characterizations helped turn Marvel's mutants into a mighty multi-media franchise. Stories he produced alongside highly talented artists like Cockrum, John Byrne, Paul Smith, John Romita Jr., and Marc Silvestri laid the foundation for blockbuster X-films, X-cartoons, and X-video games.

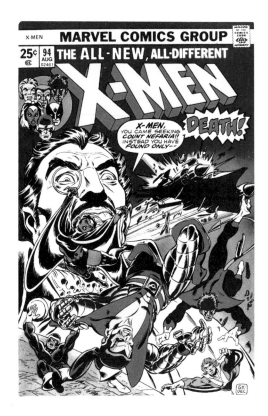

GIANT-SIZE X-MEN No. 1

Opposite: *Cover; pencils, Gil Kane; inks, Dave Cockrum; May 1975.* Squeaking in at the tail end of Marvel's experimentation with triple-length comics, *Giant-Size X-Men* featured the first appearances of the "All-New, All-Different" mutant squad. Cockrum teamed with writer Len Wein to introduce Storm, Colossus, and Nightcrawler—and to reintroduce the Wolverine!

X-MEN No. 94

Above: *Cover; pencils, Dave Cockrum; inks, Bob McLeod; August 1975.* After *Giant-Size X-Men* No. 1 relaunched the team, the *X-Men* series returned to new stories with a radically different, internationally diverse group.

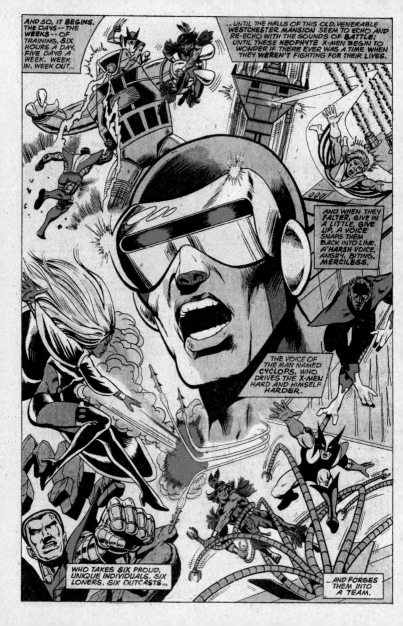

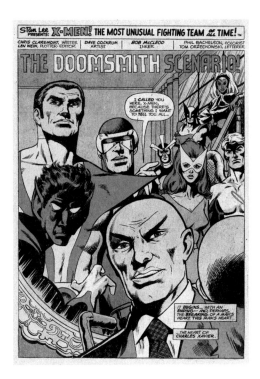

X-MEN No. 94

Opposite and above: *Interiors, "The Doomsmith Scenario!": script, Chris Claremont; pencils, Dave Cockrum; inks, Bob McLeod; August 1975.* Chris Claremont and a parade of popular artists transformed *X-Men* from a reprint title into the mutant anchor of one of Marvel's mightiest franchises. Claremont and Cockrum's work impressed readers, and sent the X-Men on their way to global stardom.

X-MEN No. 98

Above and opposite: *Interiors, "Merry Christmas, X-Men…
the Sentinels Have Returned!"; script, Chris Claremont; pencils,
Dave Cockrum; inks, Sam Grainger; April 1976.* It's a bird! It's a
plane! It's… Clark Kent and Lois Lane?!? Sure, why not?
One thing Claremont and Cockrum were having in the
X-Men's first year back on the racks was *fun*, with cameos
like Clark and Lois and DC editor Julius Schwartz filling in
the lower left corner of this art panel. The cameos didn't stop
there. *X-Men* No. 98 also featured a guest appearance from
X-Men creators Stan Lee and Jack Kirby, the latter having
returned to Marvel the previous year. But the return that
had the biggest impact for the X-Men — literally — was the
Sentinels. The deadly mutant-hunting robots had last been
seen by Marvel readers in 1969.

DIDN'T YOU *HEAR* ME, YOU BIG *LUG*--I SAID...

...*KISS ME!*

JEAN, I... I... *MMMMMM.*

HEY, STAN, YOU KNOW WHO *THEY* WERE? I TELL YA, THEY NEVER USED TO DO *THAT* WHEN *WE* HAD THE BOOK.

AH, JACK, YOU KNOW THESE *YOUNG KIDS*-- THEY GOT NO *RESPECT.*

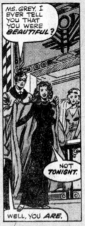

MS. GREY, I EVER TELL YOU THAT YOU WERE *BEAUTIFUL?*

NOT *TONIGHT.*

WELL, YOU *ARE.*

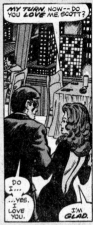

MY TURN, NOW-- DO YOU *LOVE* ME, SCOTT?

DO I... ...YES. I LOVE YOU.

I'M *GLAD.*

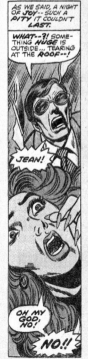

AS WE SAID, A NIGHT OF *JOY*-- SUCH A *PITY* IT COULDN'T *LAST.*

WHAT--?! SOME-THING *HUGE* IS OUTSIDE... TEARING AT THE *ROOF*--!

JEAN!

OH MY GOD, NO!

NO!!

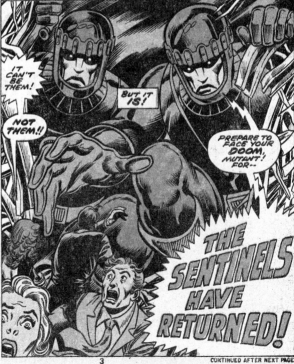

IT CAN'T BE THEM!

BUT IT *IS!*

NOT THEM!!

PREPARE TO *FACE YOUR DOOM,* MUTANT! FOR--

THE SENTINELS HAVE RETURNED!

3

CONTINUED AFTER NEXT PAGE

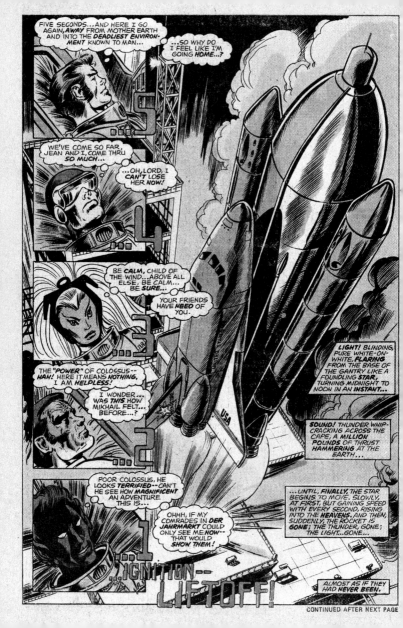

FIVE SECONDS...AND HERE I GO AGAIN, *AWAY* FROM MOTHER EARTH AND INTO THE *DEADLIEST ENVIRONMENT* KNOWN TO MAN...

...SO WHY DO I FEEL LIKE I'M GOING *HOME*...?

WE'VE COME SO FAR, JEAN AND I, COME THRU *SO MUCH*...

...OH, LORD, I *CAN'T* LOSE HER NOW!

BE *CALM*, CHILD OF THE WIND...ABOVE ALL ELSE, BE CALM... BE *SURE*...

YOUR FRIENDS HAVE *NEED* OF YOU.

THE "POWER" OF COLOSSUS-- *HAH!* HERE IT MEANS *NOTHING*, I AM *HELPLESS!*

I WONDER... WAS *THIS* HOW MIKHAIL FELT...BEFORE...?

POOR COLOSSUS, HE LOOKS *TERRIFIED*--CAN'T HE SEE HOW *MAGNIFICENT* AN ADVENTURE THIS IS...

OHHH, IF MY COMRADES IN *DER JAHRMARKT* COULD ONLY SEE ME *NOW*-- THAT WOULD *SHOW* THEM!

...IGNITION-- LIFTOFF!

LIGHT! BLINDING, PURE WHITE-ON-WHITE, *FLARING* FROM THE BASE OF THE GANTRY, LIKE A FOUNDLING *STAR*, TURNING MIDNIGHT TO NOON IN AN *INSTANT*...

SOUND! THUNDER WHIP-CRACKING ACROSS THE CAPE, A MILLION POUNDS OF THRUST HAMMERING AT THE EARTH!...

...UNTIL, *FINALLY*, THE STAR BEGINS TO MOVE. SLOWLY, AT FIRST, BUT GAINING SPEED WITH EVERY SECOND, RISING INTO THE *HEAVENS*. AND THEN, SUDDENLY, THE ROCKET IS *GONE*; THE THUNDER, GONE; THE LIGHT...GONE...

ALMOST AS IF THEY HAD *NEVER BEEN*.

CONTINUED AFTER NEXT PAGE

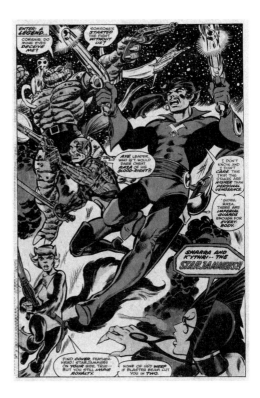

X-MEN No. 99

Opposite: *Interior, "Deathstar, Rising!"; script, Chris Claremont; pencils, Dave Cockrum; inks, Frank Chiaramonte; June 1976.* The X-Men's first foray into outer space came courtesy of Dr. Peter Corbeau's Starcore Shuttle — but it wouldn't be their last. Claremont's vision for the series expanded the team's affairs far beyond the gravity of planet Earth.

X-MEN No. 107

Above: *Interior, "Where No X-Man Has Gone Before!"; script, Chris Claremont; pencils, Dave Cockrum; inks, Dan Green; October, 1977.* The X-Men's intergalactic supporting cast came to include the Starjammers, spacefaring pirates led by the swashbuckling Corsair, who would later be revealed to be (spoiler!) the far-flung father of Scott and Alex Summers.

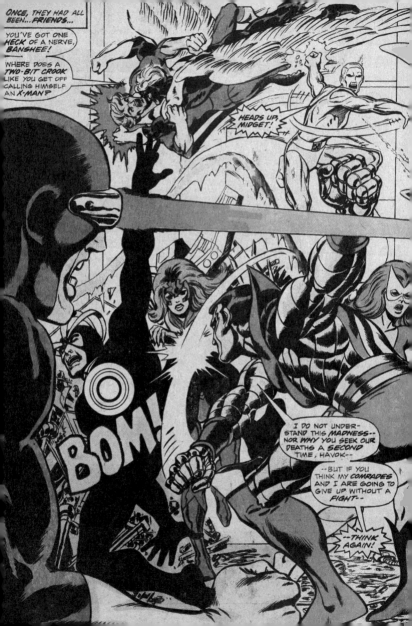

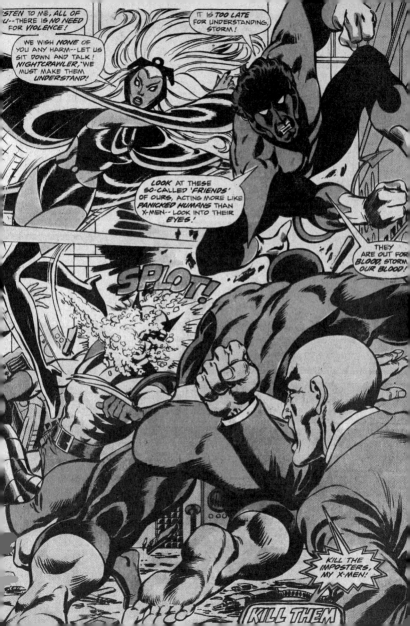

X-MEN No. 100
Previous spread: *Interior, "Where No X-Man Has Gone Before!";*
script, Chris Claremont; pencils, Dave Cockrum; inks, Dan Green;
October 1977. A battle royale between old and new mutants
headlined the milestone 100th issue of *X-Men*. The "original
X-Men" were actually X-Sentinel robots designed by the
madman Steven Lang; a seminal moment in the fight came
when a berserk Wolverine ripped the Jean Grey robot to
shreds with his adamantium claws. The shocked X-Men could
only think: *Could he do that to us?!*

OH, THANK HEAVEN
Below: *Marvel 7-Eleven Slurpee cups, 1975.* A dizzying array of
Marvel characters, including Angel and Cyclops of the X-Men,
and Beast, currently a member of the Avengers.

UNCANNY X-MEN No. 123
Opposite: *Cover; pencils and inks, Terry Austin; July 1979.* Do
you think there's something sinister about amusement parks?
Don't those rides look like deathtraps? Want to have your
worst fears played out in front of you? Step right up to evil
genius Arcade's Murderworld! Claremont and Byrne created
the baddie in *Marvel Team-Up* No. 65 (January 1978) and liked
him so much they brought him over to bother the X-Men.

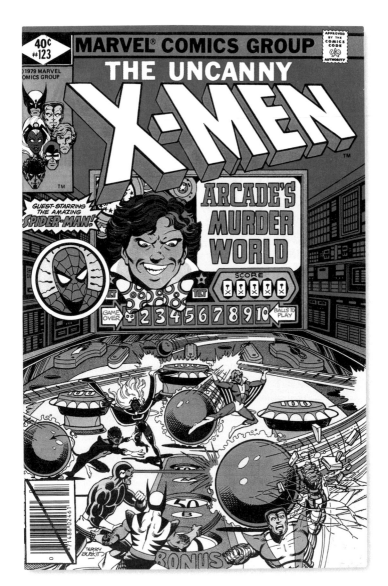

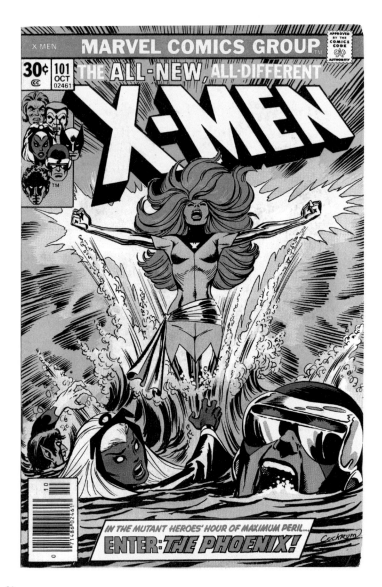

X-MEN No. 101

Opposite: *Cover; pencils and inks, Dave Cockrum; October 1976.*
"Hear me, X-Men! No longer am I the woman you knew. I am
fire! And life incarnate! Now and forever—I am Phoenix!"
proclaims Jean Grey, rising from the water uninjured (and
in a new costume) after sacrificing herself in a crash landing.
Then, she collapses. Thus begins possibly the most famous
saga in the history of the X-Men.

FINDING PHOENIX

Above: *Design sketches, Dave Cockrum, 1970s.* An inveterate
character and costume designer, Cockrum's notebooks were
filled with sketches like these, which would help conceive Jean
Grey as Phoenix. His enthusiasm was amplified in partner
Claremont, who lamented, "The X-Men are very real people to
me, and I live with them 24 hours a day. They are always on the
fringes of my thoughts, no matter how much I try to divorce
myself from them. It's a very awkward situation, because it
inhibits the writer from doing those things to characters which
must be done to keep the book dramatically viable. You don't
want to kill anyone off; you don't want to break their hearts;
you don't want to hurt them. They're your friends!"

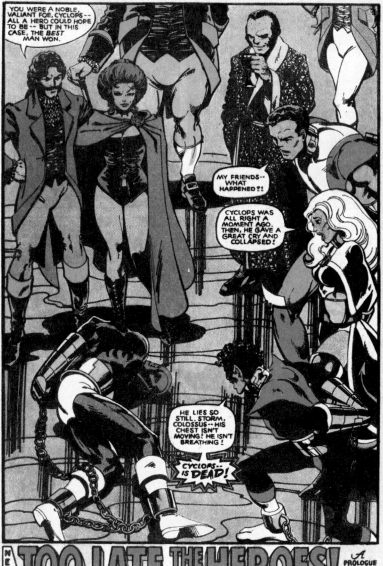

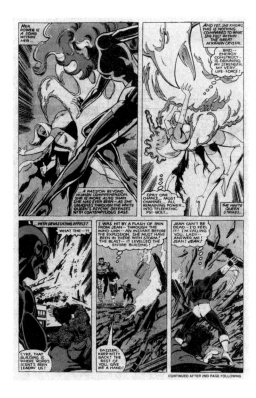

CONTINUED AFTER 2ND PAGE FOLLOWING

X-MEN No. 133

Opposite: *Interior, "Wolverine: Alone!": script, Chris Claremont; pencils, John Byrne; inks, Terry Austin; May 1980.* With readership demographics skewing older and older, Claremont delved into more adult storylines. Key among the members of the Hellfire Club was Jason Wyngarde, a visage taken by the otherwise hideous X-Men rogue Mastermind, whose psychic cruelty to Jean Grey unintentionally unleashed the Dark Phoenix force within her.

X-MEN No. 131

Above: *Interior, "Run for Your Life!": script, Chris Claremont; pencils, John Byrne; inks, Terry Austin; May 1980.* Another Hellfire Club member that would have a lasting connection to the X-Men was Emma Frost, aka the White Queen.

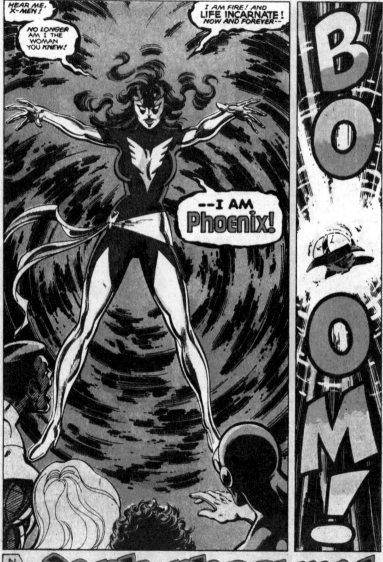

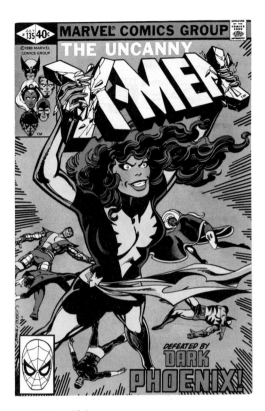

X-MEN No. 134

Opposite: *Interior, "Too Late, the Heroes!"; script, Chris Claremont; pencils, John Byrne; inks, Terry Austin; June 1980.* By the Dark Phoenix Saga's culminating issues, the creative team behind *Uncanny X-Men* was operating like a well-oiled machine: Claremont and Byrne, joined by inker Terry Austin, colorist Glynis Wein, and letterer Tom Orzechowski.

UNCANNY X-MEN No. 135

Above: *Cover; pencils, John Byrne; inks, Terry Austin; July 1980.* How powerful is the corrupted Dark Phoenix? She turns on and defeats the X-Men, then heads into space, where she feeds on a star, which results in the death of all life on an orbiting planet. The alien Shi'ar witness the event, and declare she must die.

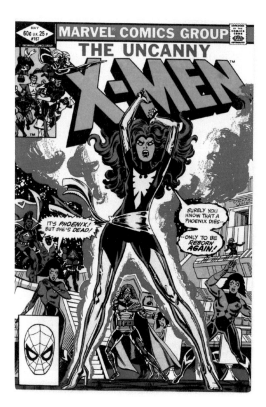

UNCANNY X-MEN No. 157

Above: *Cover; pencils and inks, Dave Cockrum; May 1982.*
So popular was the Dark Phoenix Saga that even two years
later any hint that the Phoenix might make her deadly return
sent *X-Men* readers into a tizzy. (In the case of the cover to
issue No. 157, the appearance of the Phoenix was actually a
mirage to distract the X-Men's Imperial Guard captors.)

UNCANNY X-MEN No. 164

Opposite: *Cover; pencils and inks, Dave Cockrum; December 1982.*
X-Men iconographer Dave Cockrum returned to the title with
issue No. 145 and would stay on for most of the next 20 issues.
He homaged himself in this striking cover of supporting cast
member Carol Danvers's transformation into her cosmically
powered persona, Binary.

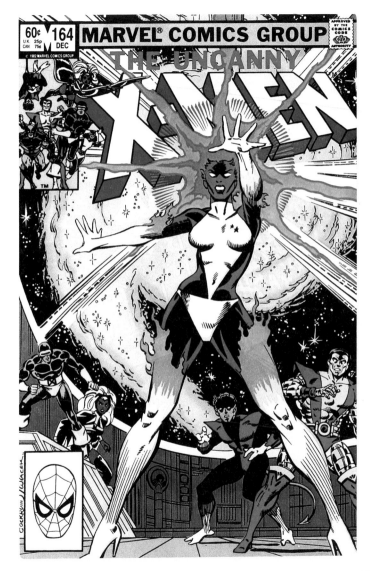

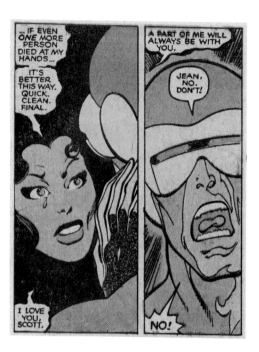

X-MEN No. 137

Above and opposite: *Interior, "The Fate of the Phoenix!"; script, Chris Claremont; pencils, John Byrne; inks, Terry Austin. Cover; pencils, John Byrne; inks, Terry Austin. September 1980.* "The Dark Phoenix Saga" reaches its heartbreaking conclusion. Jean, wracked by guilt and her inability to control the Phoenix force, tells Cyclops, "I love you, Scott. A part of me will always be with you." And then she sacrifices herself over Cyclops's protests. Later comics would alter the story's context, but Byrne and Austin's cover has become one of the most iconic in comics. "No.138," Sean Howe wrote in his 2013 *Marvel Comics: The Untold Story,* "filled with Cyclops's tormented memories of Jean, was to hopeless-romantic Marvelites what the last five minutes of *Annie Hall* were to Woody Allen fans. It sold even more copies than its predecessor."

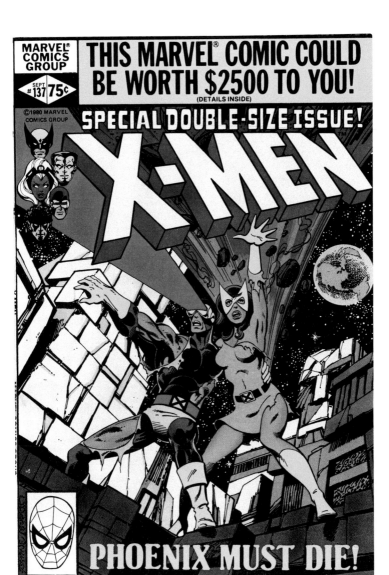

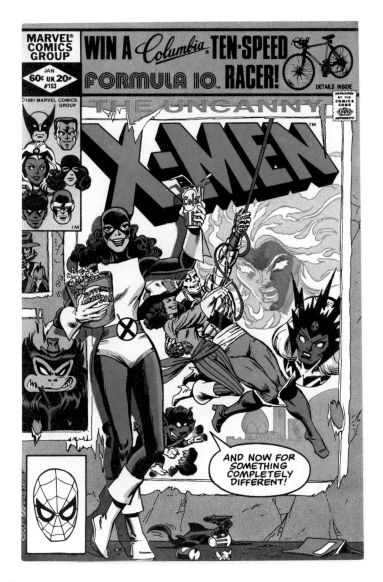

96

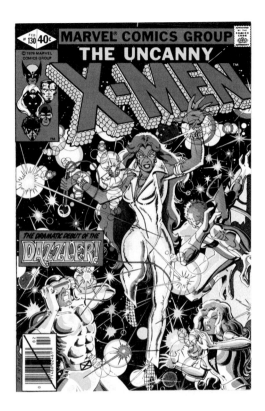

UNCANNY X-MEN No. 153

Opposite: *Cover; pencils and inks, Dave Cockrum; January 1982.* Taking the form of a bedtime story told to Colossus's little sister by Kitty Pryde, the whimsical "Kitty's Fairy Tale" has proven to be a favorite of longtime X-Men fans.

X-MEN No. 130

Above: *Cover; pencils, John Romita Jr.; inks, Terry Austin; December 1982.* Almost as impressive as the storytelling itself was Claremont and company's propensity for creating dazzling new characters — look no further than the light-manipulating mutant Dazzler herself, who made her first disco-fied appearance in the pages of *X-Men* before receiving her own title a year later.

X-MEN HOUSE AD

Below: *House ad; art, Dave Cockrum; 1979.* Four years after the debut of the "All-New, All-Different" X-Men, the series was finally upgraded to monthly status, as hyped by house ads in that summer's Marvel comics. Also hyped? Their world-class creative team.

X-MEN No. 121

Opposite: *Interior, "Shoot-Out at the Stampede!"; script, Chris Claremont; pencils, John Byrne; inks, Terry Austin; May 1979.* Another of *X-Men's* contributions to the cavalcade of Marvel Universe characters was Alpha Flight, Canada's first super-team, led by the Maple Leaf–wearing Vindicator (who had previously tussled with the X-Men as Guardian in *X-Men* No. 109). Alpha Flight would get their own long-running title, written and drawn by their cocreator and fellow Canadian John Byrne.

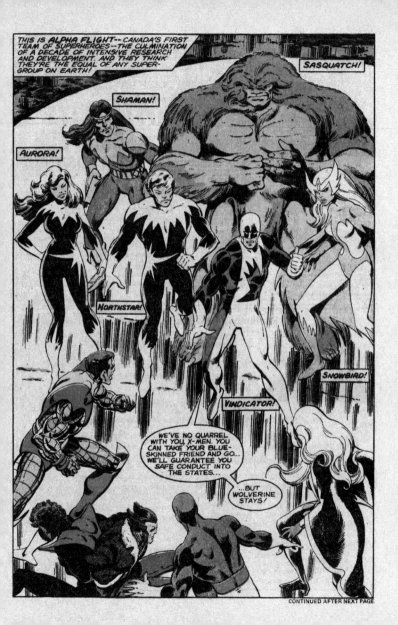

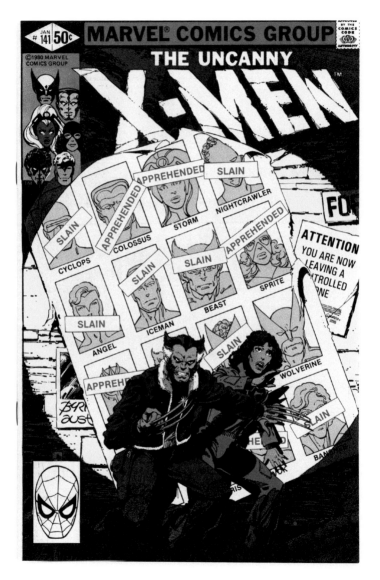

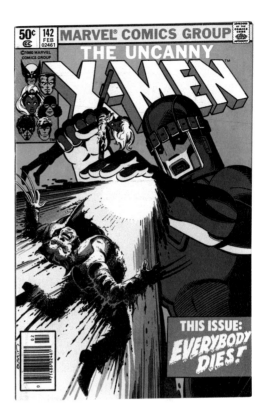

X-MEN No. 141

Opposite: *Cover; pencils, John Byrne; inks, Terry Austin; January 1981.* A lot of storytelling was packed into the "Days of Future Past" arc, which depicted an alternate future of the X-Men in a world sundered by mutant/human conflict.

UNCANNY X-MEN No. 142

Above: *Cover; pencils and inks, Terry Austin; February 1981.* Do the Sentinels win?!? In any case, the second and final part of "Days of Future Past," the time-bending inspiration for the 2014 film, continued a creative hot streak for Chris Claremont and John Byrne, an X-Men dream team that would sadly come to an end after only one more issue. With this issue, the series would formally change its name from *X-Men* to *Uncanny X-Men* in the indicia.

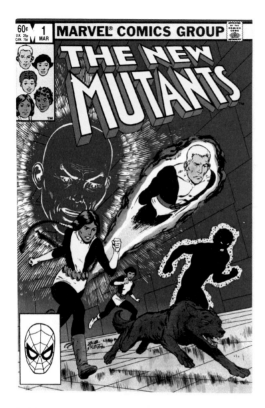

NEW MUTANTS No. 1

Above: *Cover, original art; pencils and inks, Bob McLeod; March 1983.* By 1983, it was clear that more room was needed on the schedule to satiate mutant mania. The newest class at Xavier's school included Karma (who had previously appeared as an antagonist in *Marvel Team-Up* No. 100), and surrounded her with fellow mutants Cannonball, Mirage, Sunspot, and Wolfsbane.

NEW MUTANTS No. 25

Opposite: *Cover; art, Bill Sienkiewicz; March 1985.* Initially drawn by pros like Bob McLeod and Sal Buscema, *New Mutants* was soon handed to brash young illustrator Bill Sienkiewicz, who expanded the visual palette of the series with a frenetic style that pushed as many visual boundaries as Frank Miller's pioneering work on *Daredevil*.

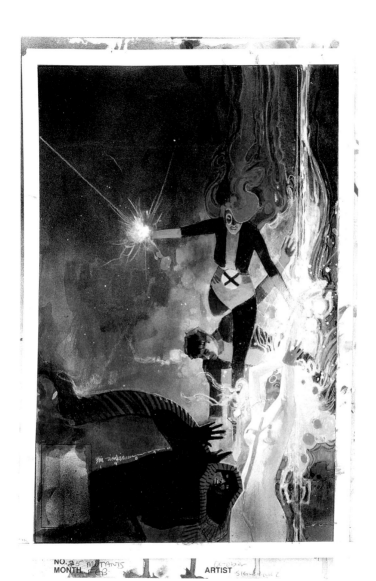

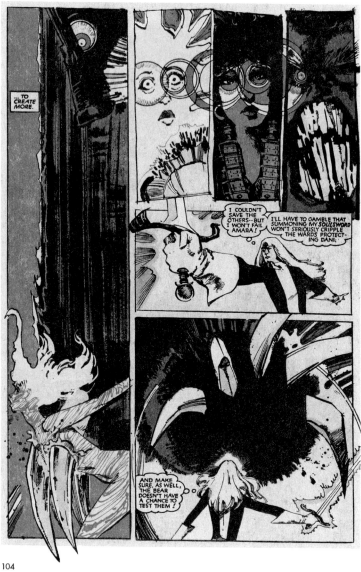

NEW MUTANTS No. 20

Opposite: *Interior, "Badlands"; script, Chris Claremont; pencils and inks, Bill Sienkiewicz; October 1984.* "I saw someone on the train reading Hunter Thompson's The Curse of Lono, which [Ralph] Steadman illustrated, and laughing hysterically. I bought the book, read it, saw the visuals, and also read Thompson's descriptions of Steadman, who's a character in the book, and they're hilarious. I didn't feel consciously influenced by him at the time, but I seemed to fall into it when I started doing the Bear." — Bill Sienkiewicz

NEW MUTANTS No. 26

Above: *Cover; art, Bill Sienkiewicz; April 1985.* Sienkiewicz used his idiosyncratic style to great effect in otherwise main-stream titles, like *New Mutants* and *Moon Knight*.

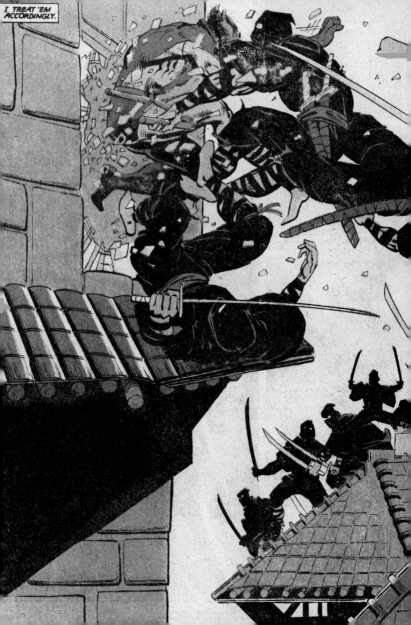

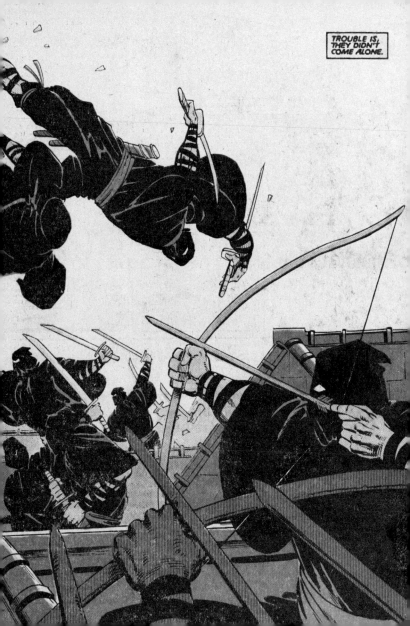

WOLVERINE No. 1

Previous spread: *Interior, "I'm Wolverine."; script, Chris Claremont; pencils, Frank Miller; finishes and inks, Joe Rubinstein; September 1982.* Frank Miller's obsessions with Japanese subject matter were a defining trait of his collaboration with Chris Claremont on the four-issue *Wolverine* miniseries, which filled in Logan's mysterious backstory with hints of a long history spent in Japan. And, as in many a Miller comic, ninjas abound.

X-MEN No. 132

Below: *Interior, "And Hellfire Is Their Name!"; script, Chris Claremont; pencils, John Byrne; inks, Terry Austin; April 1980.* The end of this issue teased that Wolverine would be fighting solo next month. (The rest of the X-Men were captive upstairs.) It wouldn't be long before Logan had his own comics.

WOLVERINE No. 2

Opposite: *Cover; pencils, Frank Miller; inks, Joe Rubinstein; October 1982.* Wolverine was just the first of many X-Men characters to spin off into their own miniseries, as the 22 pages of the monthly flagship title weren't enough to keep up with the burgeoning plotlines.

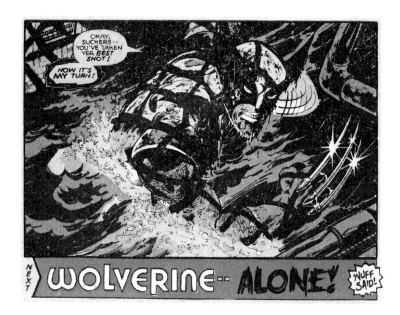

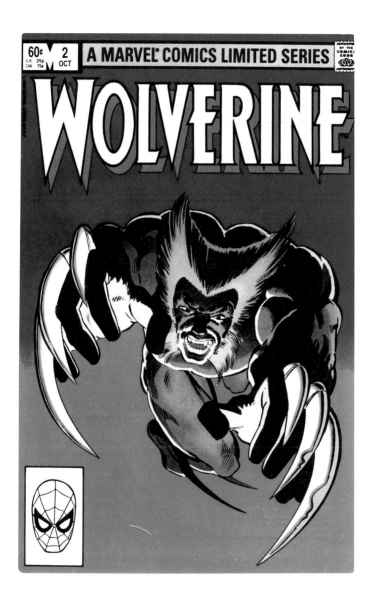

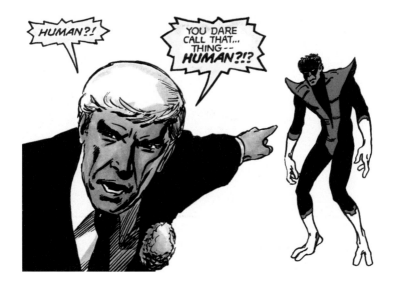

FEARED AND HATED

Above: *Interior,* Marvel Graphic Novel *No. 5:* X-Men – God Loves, Man Kills: *script, Chris Claremont; pencils and inks, Brent Anderson; 1982. God Loves, Man Kills* opened with the brutal killing of two adolescent mutants by the mutant-hating Purifiers. In the end, their leader — the evangelist Richard Stryker — and his mission of hate, is exposed by the X-Men. The graphic novel was an instant hit and became an evergreen story in the X-Men canon. "We wanted something that would read as good, we hoped, in 5 years if not 20, as it did in that day," remarked writer Chris Claremont in a 2007 interview.

MARVEL GRAPHIC NOVEL No. 5

Opposite: *Cover; pencils and inks, Brent Anderson; 1982.* While regular artist on *Ka-Zar the Savage,* artist Brent Anderson merely dabbled in the X-Men, drawing an issue or an annual here and there, but he stepped into the spotlight in a big way with his (and colorist Steve Oliffe's) lush work on *God Loves, Man Kills.*

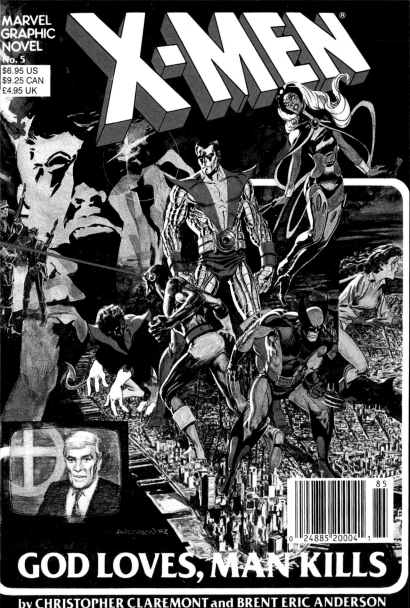

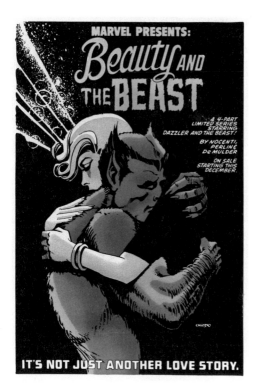

BEAUTY AND THE BEAST

Above: *House ad; art, Joe Chiodo; December 1983.* More mutant miniseries filled the schedule after *Wolverine*, including one starring Beast and Dazzler in the aptly titled *Beauty and the Beast*. Dazzler's pop star career derails after being outed as a mutant in this four-issue series by Ann Nocenti and Don Perlin, with cover art by Bill Sienkiewicz.

UNCANNY X-MEN No. 171

Opposite: *Interior, "Rogue"; script, Chris Claremont; pencils, Walter Simonson; inks, Bob Wiacek; July 1983.* Recently named leader of the X-Men, Storm also wrests leadership of the subterranean-dwelling mutant rejects the Morlocks in an issue drawn by *Thor* delineator (and husband of *X-Men* editor Louise Simonson) Walter Simonson.

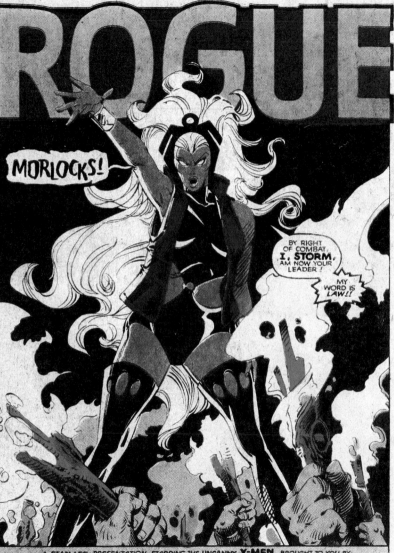

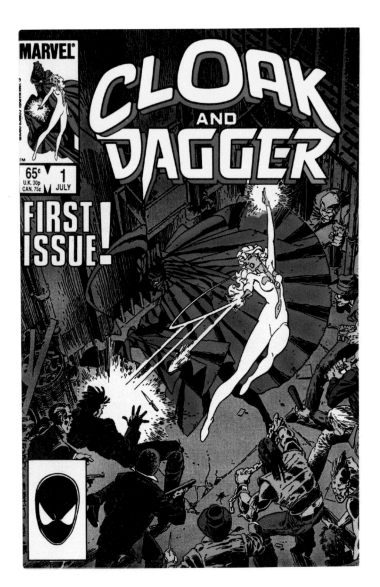

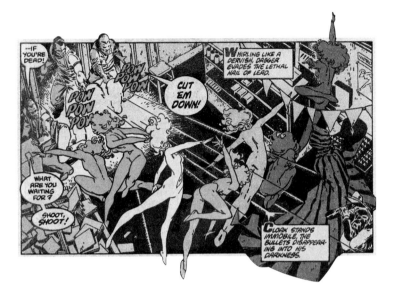

CLOAK AND DAGGER No. 1

Opposite: *Cover; pencils, Rick Leonardi; inks, Terry Austin; July 1985.* Created by Bill Mantlo and Ed Hannigan, Cloak and Dagger debuted in a 1982 issue of *Spectacular Spider-Man* with a hard-edged origin: Ty Johnson and Tandy Bowen were teen runaways who survived involuntary narcotic experiments, gaining powers over darkness and light, respectively. They received a miniseries the next year, and their own title in 1985.

NEWER MUTANTS

Above: *Interior,* Cloak and Dagger *mini-series No. 1: "Chapter One: The Priest"; script, Bill Mantlo; pencils, Rick Leonardi; inks, Terry Austin; October 1983.* Though not revealed to be mutants until later in the decade, Cloak and Dagger were another example of mutantkind blossoming during the X-Men mania of the '80s.

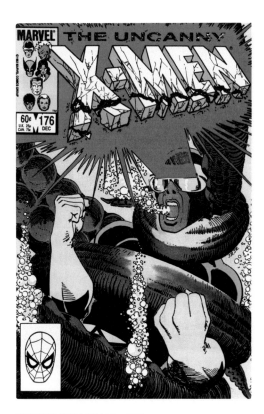

UNCANNY X-MEN No. 176

Above: *Cover; pencils, John Romita Jr.; inks, Bob Wiacek; December 1983.* "JRJR" took over as artist in this issue, having proven himself with runs on *Iron Man* and *Amazing Spider-Man*, as well as early issues of *Dazzler*. Romita would make a mark on the X-Men, drawing the series through the end of 1986.

UNCANNY X-MEN No. 150

Opposite: *Cover; pencils, Dave Cockrum; inks, Joe Rubinstein; October 1981.* The X-Men's most maniacal '60s antagonist developed a more nuanced relationship with them in the '80s. Magneto's desire to protect his mutant brotherhood by any means necessary gained poignancy as the extent of mutant hatred was revealed —along with his own background as a Jewish survivor of Nazi concentration camps.

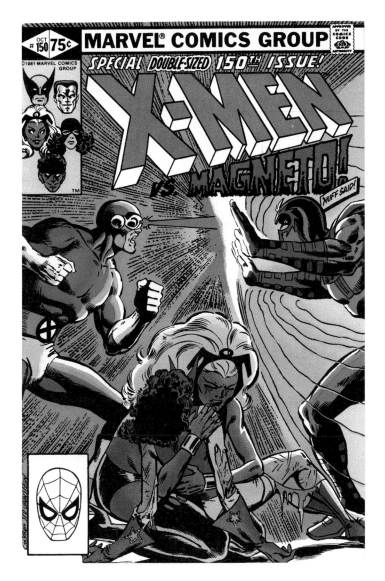

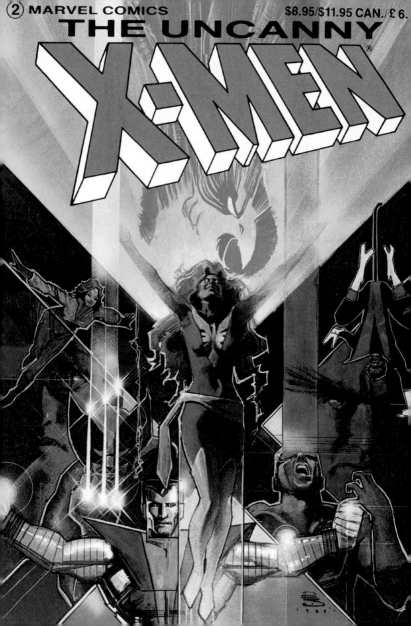

BONUS FEATURE!
IF JEAN GREY HAD LIVED, X-MEN #138 WOULD HAVE
BEGUN WITH THIS IDYLLIC SPLASH PAGE . . .

. . . INSTEAD OF THE GRAVEYARD
SCENE WHICH WAS USED INSTEAD.

PROUDLY RE-PRESENTING . . .

Opposite: *Book cover,* The Uncanny X-Men; *art, Bill Sienkiewicz;*
1984. In addition to publishing original graphic novels,
in 1984 Marvel began the now-industry-standard tradition
of collecting past issues into the trade paperback "graphic
novel" format. This volume gathers "The Dark Phoenix Saga"
from *X-Men* issues 129–137.

PHOENIX: THE UNTOLD STORY No. 1

Above: *Interior,* "The Fate of the Phoenix!"; *script, Chris*
Claremont; pencils, John Byrne; inks, Terry Austin; April 1984.
In a rare occurrence, key *X-Men* issue 137 was reprinted
with an alternate ending.

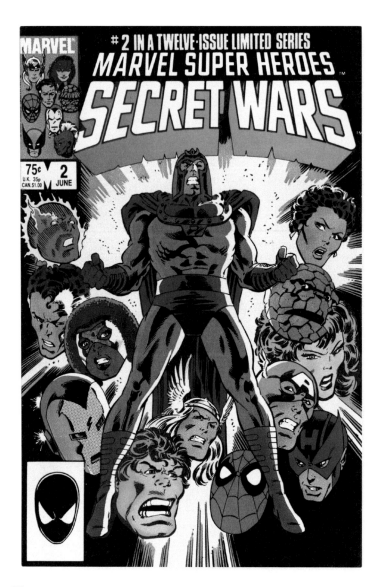

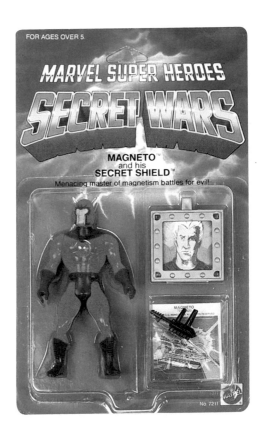

MARVEL SUPER HEROES SECRET WARS No. 2

Opposite: *Cover: pencils, Mike Zeck; inks, John Beatty; June 1984.*
"Super heroes" may have been in the title of Jim Shooter's
mega-popular comic book maxiseries, but the villains had
their role, too. Magneto joined many others to vie for victory
in the Beyonder's Battleworld — and inspire kids to go buy
the action figures at Toys "R" Us!

STAGE YOUR OWN BATTLES

Above: *Action figure, Mattel, 1984.* Secret Wars tie-in toys by
Mattel featured articulated plastic figures with painted-on
costumes, a far cry from the doll-like Marvel toys made by
Mego in the 1970s, with cloth apparel.

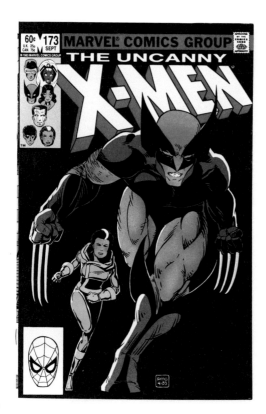

UNCANNY X-MEN No. 173
Above: *Cover; pencils and inks, Paul Smith; September 1983.*
There was no question that Wolverine was the X-Men's
breakout star. He took center stage on this cover (with Rogue)
and in the issue's story, the Chris Claremont–written, Smith–
drawn "To Have and Have Not."

UNCANNY X-MEN No. 210
Opposite: *Cover; pencils, John Romita Jr.; inks, Bob Wiacek;
October 1986.*

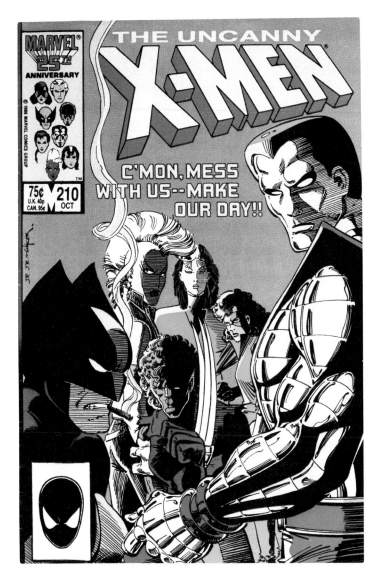

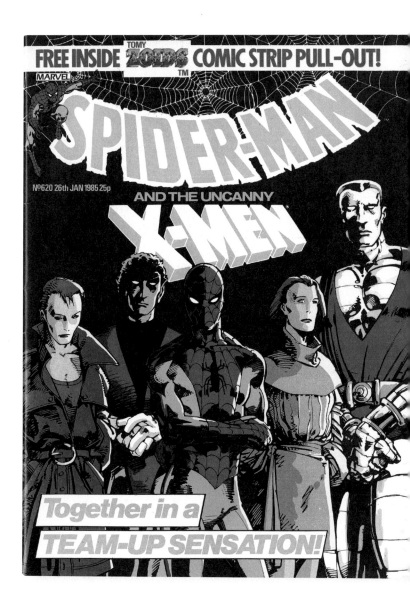

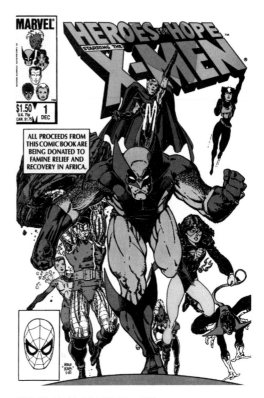

SPIDER-MAN COMIC No. 620

Opposite: *Cover; pencils and inks, Barry Windsor-Smith; January 1985.* Marvel U.K.'s weekly *Spider-Man Comic*, largely featuring American reprints, had been running for more than a decade before it featured Spidey's adventure with the X-Men from *Marvel Team-Up* No. 150 (February 1985). The unique stylings of Barry Windsor-Smith on the cover would have stood out from other comics on British newsstands at the time.

HEROES FOR HOPE STARRING THE X-MEN

Above: *Cover; pencils and inks, Arthur Adams; December 1985.* All-star contributors to this African famine relief charity jam included writers Stan Lee, Chris Claremont, Harlan Ellison, Stephen King, and George R. R. Martin, and artists Frank Miller, Mike Kaluta, Steve Rude, and Bernie Wrightson.

UNCANNY X-MEN No. 198

Above: *Cover; pencils, inks, and colors, Barry Windsor-Smith;
October 1985.* Barry Windsor-Smith's first art credit in comics
was a 1969 issue of *X-Men* that saw him aping his hero, Jack
Kirby. By the mid-'80s, Windsor-Smith had arrived as one of
the most extraordinary illustrators in the field. He returned
to *Uncanny X-Men* periodically to spell the book's regular artist,
John Romita Jr., coplotting, penciling, inking, and coloring
in his gorgeously illustrative style.

UNCANNY X-MEN No. 251

Opposite: *Cover; pencils, Marc Silvestri; inks, Dan Green; Early
November 1989.* The striking figure of Wolverine crucified
on an X came from the pencil of Marc Silvestri, the regular
Uncanny artist since issue No. 218.

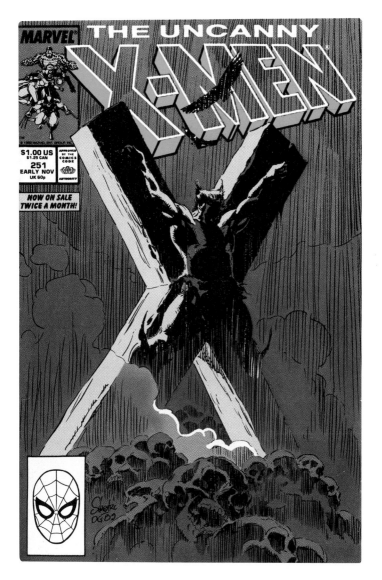

X-FACTOR No. 1

Above: *Interior, "Third Genesis"; script, Bob Layton; pencils, Jackson Guice; inks, Jackson Guice, Bob Layton, Joe Rubinstein; February 1986.* X-Factor revived the original quintet of X-Men to pose as a band of mutant hunters, the better to liberate them instead. Cyclops, who had been drifting away from the X-Men, joined the trio of Iceman, Angel, and the Beast, who had just left the disbanded Defenders, and finishing out the group was a returned-from-the-dead Jean Grey.

X-FACTOR No. 1

Opposite: *Cover; pencils, Walter Simonson; inks, Joe Rubinstein; February 1986.* Writer Kurt Busiek concocted a way to resurrect Jean Grey, allowing her to become the fifth member in *X-Factor*.

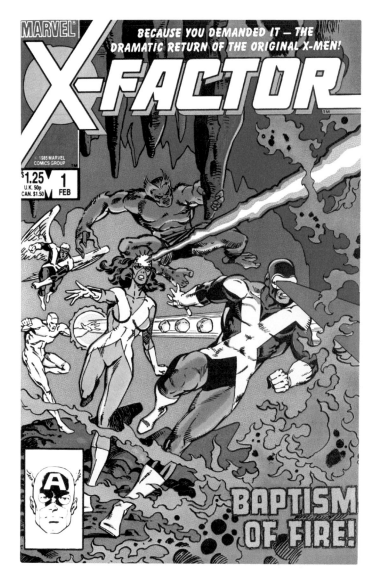

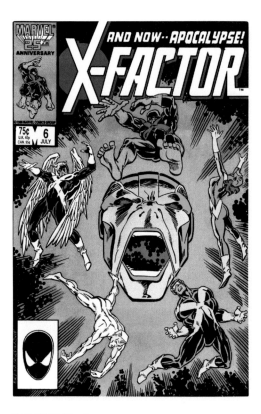

X-FACTOR No. 6

Above: *Cover: pencils, Ron Frenz; inks, Joe Rubinstein; July 1986.*
The editor of *Uncanny X-Men* through its industry-changing
early '80s run, Louise Simonson left that gig to take on full-time
writing, with long runs on *New Mutants* and *X-Factor.*

UNCANNY X-MEN No. 240

Opposite: *Cover: pencils, Marc Silvestri; inks, Dan Green;
January 1989.* Crossover events that joined together the *X-Men*
titles had grown bigger and bigger since "Mutant Massacre"
kicked off the trend in 1986. "Inferno" topped them all, with a
four-issue miniseries tying together the three ongoing X-books
and sprawling across other Marvel titles. The threat? Cyclops'
ex-wife Madelyne Pryor, as the Goblin Queen, unleashes the
hordes of Limbo in a plot devised by the evil Mister Sinister.

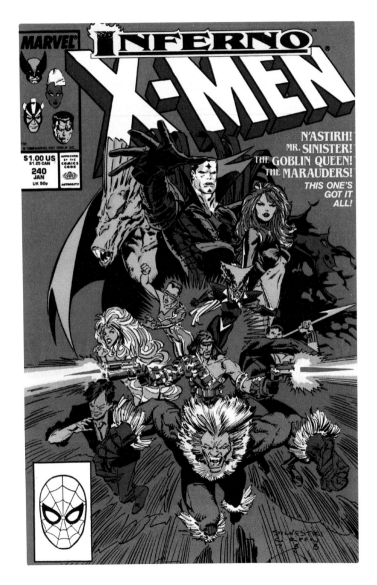

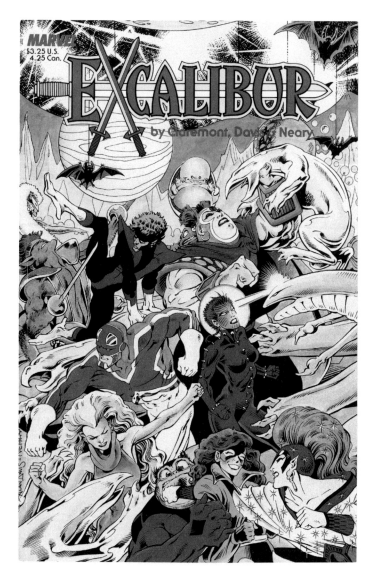

EXCALIBUR: THE SWORD IS DRAWN

Opposite: *Cover; pencils, Alan Davis; inks, Paul Neary; December 1987.* The fourth ongoing *X-Men* series saw mutant maestro Chris Claremont and British artist Alan Davis relocate a handful of popular X-Men to England (Kitty Pryde, Nightcrawler, and Rachel Summers) to unite with Captain Britain and his metamorph girlfriend, Meggan, under the banner of Excalibur.

UNCANNY X-MEN No. 271

Below: *Interior; "Flashpoint!"; script, Chris Claremont; pencils, Jim Lee; inks, Scott Williams; December 1990.* With the number of X-titles on the rise, comic book continuity grew ever more convoluted and complex — but not many mutants can boast a backstory more confusing than Psylocke's. British telepath Betsy Braddock (sister of Captain Britain, no less) first joined the X-Men back in *New Mutants Annual* No. 2 (1986). But by 1990, she could be found in the (scantily clad) body of a Japanese ninja.

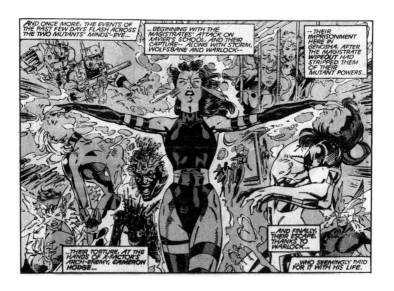

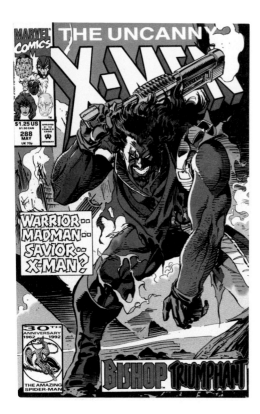

UNCANNY X-MEN No. 288

Above: Cover; pencils, Andy Kubert; inks, Tom Orzechowski; May 1992. In the '90s, gun-toting time-travelers were in vogue — and this cover features the second best of all, Lucas Bishop. Hailing from a nightmare future where mutants have an "M" tattooed on their faces, there is one first prize Bishop can claim — he is without doubt the coolest X-Man with a mullet.

UNCANNY X-MEN No. 266

Opposite: Cover; pencils and inks, Andy Kubert; August 1990. One of the most enduringly popular X-Men of the '90s was Remy LeBeau. With energy-charged playing cards, an outrageous patois, a hidden history with Storm, and an intrigue with Rogue, Gambit would soon become a fan favorite.

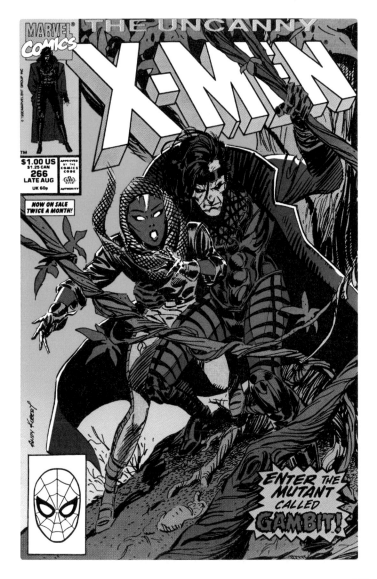

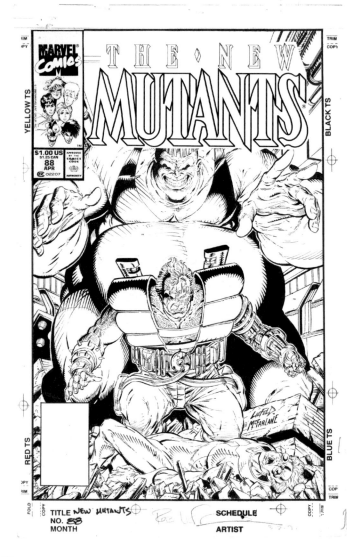

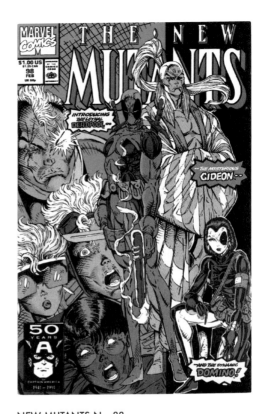

NEW MUTANTS No. 88

Opposite: *Original cover art; pencils, Rob Liefeld; inks, Todd McFarlane; April 1990.* Cable first appeared in *New Mutants* No. 87 (March 1990) as the group's new militaristic leader, and he stole the spotlight for the second cover in a row—with the pencils of one blockbuster artist on the rise, inked by another!

NEW MUTANTS No. 98

Above: *Cover; pencils and inks, Rob Liefeld; February 1991.* It was his first appearance on a comic book cover—far from his last. Another Liefeld cocreation, Deadpool began life as a sparring partner for Cable, but went on to establish himself as a wise-cracking, fourth wall–breaking comic book phenomenon. "Merc with a Mouth" Wade Wilson went on to star in multiple series and even his own record-breaking, R-rated movie.

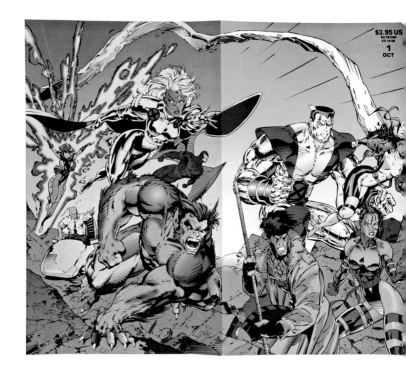

X-MEN No. 1

This spread: *Cover: pencils, Jim Lee; inks, Scott Williams; October 1991. X-Men*, an all-new series with art by Jim Lee, launches with four covers that together make one giant illustration — also available as a fifth fold-out cover. "The world has changed; the characters have changed," Jim Lee told *Marvel Age* before the premiere issue hit the shelves. "It's not like we've tried to take the book thirty years back in time…" With a series of four interconnecting covers that displayed a dramatic tableau of X-Men in battle against Magneto, they struck the right chord as, voilà! — eight million copies sold. Later that yeasr, Sotheby's first-ever comic art auction sells the complete pages to Jim Lee's *X-Men* No. 1 for $44,000. (Pages from *Amazing Spider-Man* No. 31, by Lee and Ditko, net $20,000.)

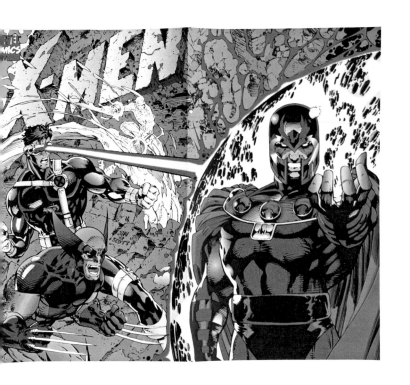

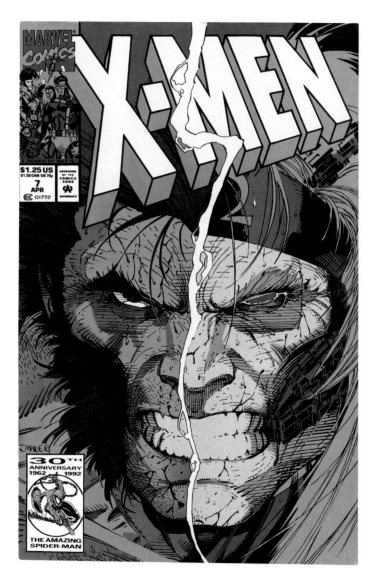

140

X-MEN No. 7

Opposite: *Cover; pencils, Jim Lee; inks, Art Thibert; April 1992.*
The dynamic flair and intricate linework of wildly popular
X-Men artist Jim Lee is demonstrated on this eye-catching
portrait cover depicting a split-image of both Wolverine and
his bitter enemy, the deadly KGB supersoldier, Omega Red.

JIM "DON'T CALL ME HAPPY" LEE

Above: *Photograph, Greg Preston; Jim Lee at WildStorm Studio,
San Diego, California; 1987.* Jim Lee's first Marvel work was
a regular gig on *Alpha Flight*, where he developed the highly
detailed art style that put him on the path to stardom, along-
side peers Todd McFarlane, Rob Liefeld, and Marc Silvestri.

X-FORCE No. 1

Following spread: *Interior, "A Force to Be Reckoned With";
script, Fabian Nicieza; plot, pencils, and inks, Rob Liefeld; August
1991.* In the early '90s, few artists were as scorching hot as
Rob Liefeld. He could do no wrong as far as the fans were
concerned, and sales for his new series *X-Force* proved it. The
shipping of five extra variants, each bagged with trading
cards, might have helped, too.

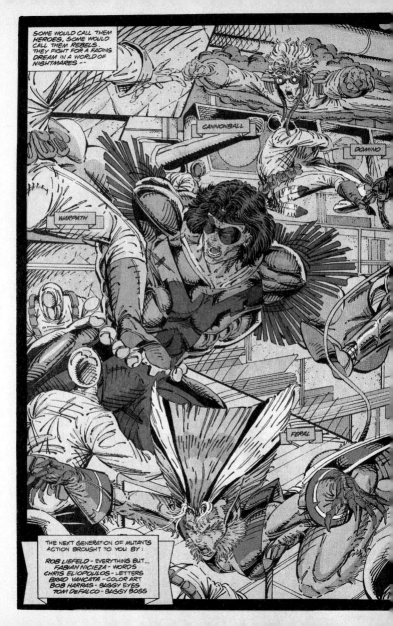

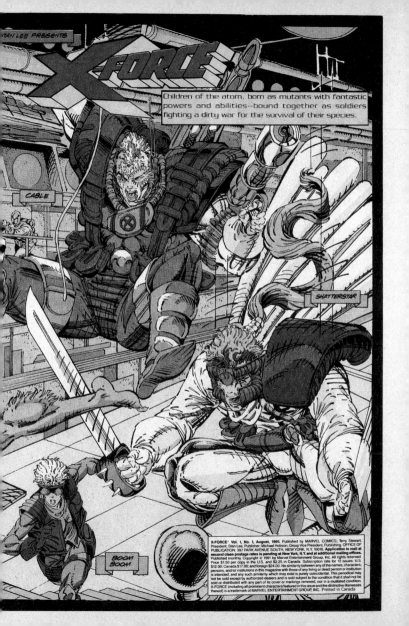

STAN LEE PRESENTS

X-FORCE

Children of the atom, born as mutants with fantastic powers and abilities--bound together as soldiers fighting a dirty war for the survival of their species.

CABLE

SHATTERSTAR

BOOM BOOM

X-FORCE® Vol. 1, No. 1, August, 1991. Published by MARVEL COMICS: Terry Stewart, President; Stan Lee, Publisher; Michael Hobson, Group Vice President, Publishing. OFFICE OF PUBLICATION: 387 PARK AVENUE SOUTH, NEW YORK, N.Y. 10016. Application to mail at second class postage rates is pending at New York, N.Y. and at additional mailing offices. Published monthly. Copyright © 1991 by Marvel Entertainment Group, Inc. All rights reserved. Price $1.50 per copy in the U.S. and $2.25 in Canada. Subscription rate for 12 issues: U.S. $12.00; Canada $17.00; and foreign $24.00. No similarity between any of the names, characters, persons, and/or institutions in this magazine with those of any living or dead person or institution is intended, and any such similarity which may exist is purely coincidental. This periodical may not be sold except by authorized dealers and is sold subject to the condition that it shall not be sold or distributed with any part of its cover or markings removed, nor is a mutilated condition. X-FORCE (including all prominent characters featured in this issue and the distinctive likenesses thereof) is a trademark of MARVEL ENTERTAINMENT GROUP, INC. Printed in Canada.

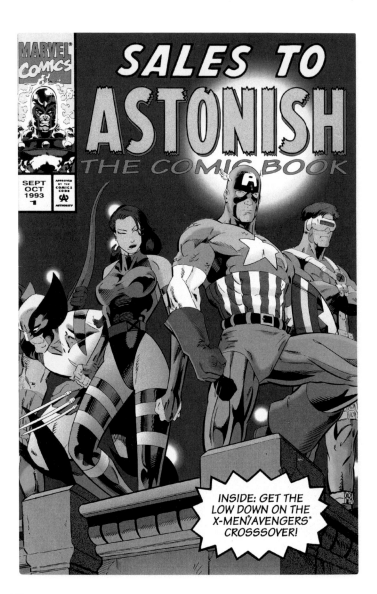

SALES TO ASTONISH No. 1

Opposite: *Cover: pencils, Jeff Johnson; inks, Mark McKenna; September/October 1993.* With the impending crossover, "Bloodties," planned to celebrate the joint 30th anniversaries of the Avengers and the X-Men, Marvel gave over an issue of its (very) short-lived promotional comic book *Sales to Astonish* to publicize the event.

MARVEL UNIVERSE TRADING CARDS

Above: *Trading cards, Impel, 1990.* The baseball card industry entered into a short but lucrative love affair with super heroes. Marvel's first set contained 162 cards and five hologram "chaser" cards. The sets included "rookie cards" of each year's new heroes.

145

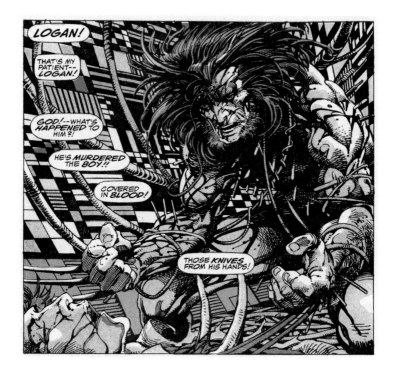

MARVEL COMICS PRESENTS No. 74

Above: *Interior; "Weapon X"; script, pencils, and inks, Barry Windsor-Smith; April 1991.* One of the greatest Wolverine stories ever told took place not in his own solo series, nor an *X-Men* title, but in an anthology title. Barry Windsor-Smith's brutally brilliant tale, told across 12 short chapters, began in *Marvel Comics Presents* No. 72 (March 1991), and revealed how the Weapon X program gave the man called Logan his adamantium skeleton — and how that process turned him into a feral killing machine.

MARVEL COMICS PRESENTS No. 94

Opposite: *Cover; pencils and inks, Sam Kieth; January 1992.* Arguably the most popular character in comic books at the time, Wolverine came to dominate *Marvel Comics Presents* — in particular its covers — to such an extent that it was practically his second ongoing series.

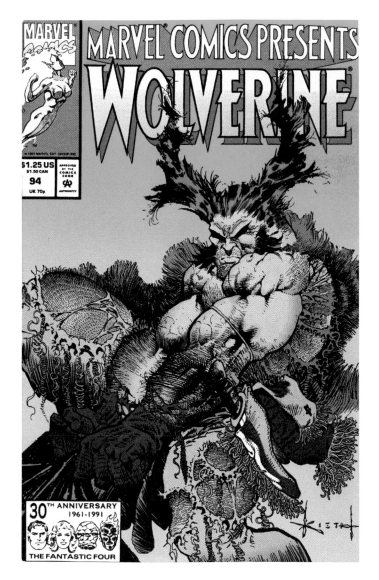

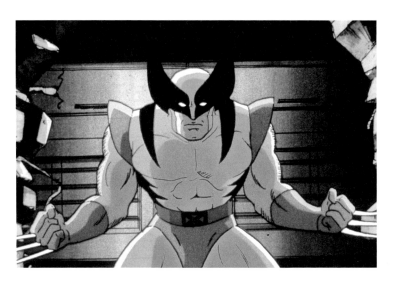

PRYDE OF THE X-MEN

Opposite: *Animation still,* Pryde of the X-Men, *Marvel Productions, 1989. Pryde of the X-Men* was a failed pilot for Marvel Productions' first attempt at an animated series for the Children of the Atom—perhaps most notorious for featuring a Wolverine with an Australian accent, long before Hugh Jackman would famously take on the role.

X-MEN: THE ANIMATED SERIES

Above: *Animation still, Fox Kids, 1992.* The profound effect on comics fandom of the animated X-Men cannot be overstated. During its high-rated five-year run on Fox Kids, it reached an audience far larger and more diverse than any comic title— even as the industry was riding high on a tidal wave of sales. Millions of little minds—a hefty percentage of whom were girls —thrilled to the Saturday-morning adventures of Cyclops, Rogue, Jubilee, and Wolverine, arguably propelling the Millenial super hero movie mania more than anything else before or since.

" JUST AS THE *ADAMANTIUM* WAS *BONDED* TO WOLVERINE'S *BONES!*

" TO INDISCRIMINATELY EXCISE THESE MEMORIES WOULD BE AS DAMAGING TO HIS *MIND* AS MAGNETO'S FORCED EXTRACTION OF WOLVERINE'S *ADAMANTIUM* WAS TO HIS *BODY!*

" AS... DAMAGING AS WHAT I *DID* TO MAGNETO...

HOW CAN WE JUST STAND BY HERE AND DO *NOTHING.* WHAT WAS THE *PURPOSE* OF COMING IN HERE?

TO WAIT AND WATCH AND TO BE PREPARED TO COUNTER THE COLLAPSE OF THE *MATRIX* UPON WHICH THE WEB OF HIS PERSONALITY IS SPUN;

TO BE *ENCOURAGEMENT* IN THE REALM OF *DESPAIR!*

TO BE *FRIENDS* AT THE BRINK OF THE ULTIMATE *LONELINESS.*

WOLVERINE No. 75

Opposite: *Interior; "Nightmares Persist"; script, Larry Hama; pencils, Adam Kubert; inks, Mark Farmer, Dan Green, Mark Pennington; November 1993.* In the dramatic culmination of the "Fatal Attractions" crossover, Magneto delivered one of the most jaw-dropping moments in X-Men history — as he stripped the very adamantium from Wolverine's skeleton. The stunning storyline answered one long-standing query — Logan's claws remained as part of his mutation, only now made purely from bone.

ADVENTURES OF CYCLOPS AND PHOENIX No. 4

Above: *Interior; "Sacrifice"; script, Scott Lobdell; pencils, Gene Ha; inks, Bill Anderson, Al Milgrom, Josef Rubinstein, Al Vey; August 1994.*

X-MEN No. 30

Below: *Cover; pencils, Andy Kubert; inks, Matt Ryan; March 1994.*
For three decades, the Scott Summers–Jean Grey romance
had kept readers gripped — through Phoenix's "death,"
Cyclops marrying her clone, and countless other complications.
Finally, in 1994, fans could have tissues at the ready for the
moment they had long been waiting for — as Jean and Scott
tied the knot.

MARVELS No. 2

Opposite: *Cover; art, Alex Ross; 1994.* As if to drive home the
novelty of the artist's photo-realistic style, the protagonist of
Marvels was Phil Sheldon, a photojournalist for the Daily
Bugle. Through his camera lens, readers were treated to
writer Kurt Busiek's love letter to Marvel's beginnings, as
seen from the earthbound view of the average citizen, like this
perspective of a hostile crowd raging at the X-Men's Angel.
The lush, reverential *Marvels* was quite the contrast with the
typical fare of early '90s Marvel — with its variant covers,
holograms, and exaggerated anatomy.

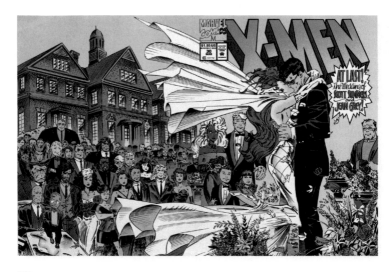

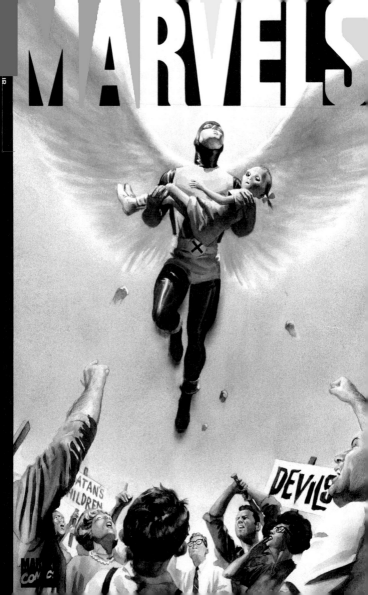

X-MEN No. 44
Above: *Cover; pencils, Andy Kubert; inks, Cam Smith; September 1995.* A fighting mad Cyclops blasted his way toward the reader, through wreckage and the X-Men logo, in this bombastic cover by the latest superstar artist to grace the title, Andy Kubert.

GENERATION X No. 1
Opposite: *Cover; pencils, Chris Bachalo; inks, Mark Buckingham; November 1994. Generation X* stood out as artist Chris Bachalo's first showcase at Marvel. His rendition of a team of junior league X-Kids showed a rapid evolution in style; his stunning character designs and electrifying layouts soon coalesced into his trademark.

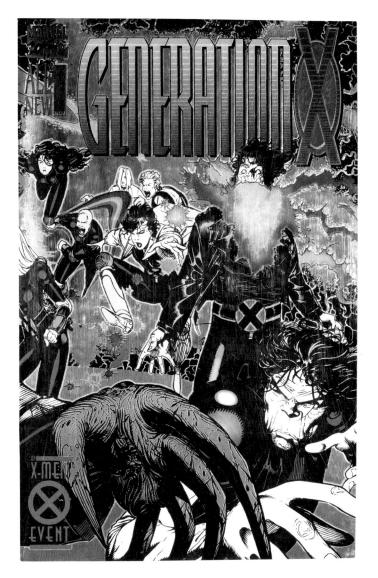

155

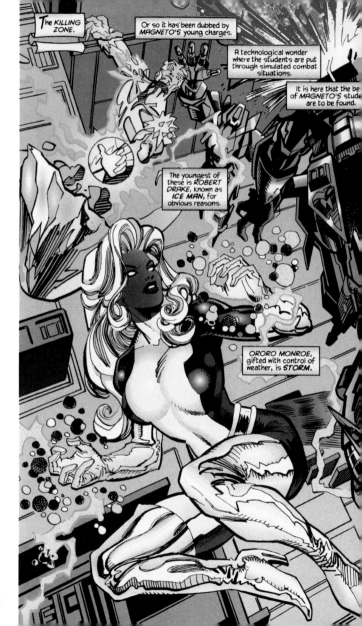

The KILLING ZONE.

Or so it has been dubbed by MAGNETO'S young charges.

A technological wonder where the students are put through simulated combat situations.

It is here that the be of MAGNETO'S stud are to be found.

The youngest of these is ROBERT DRAKE, known as ICE MAN, for obvious reasons.

ORORO MONROE, gifted with control of weather, is STORM.

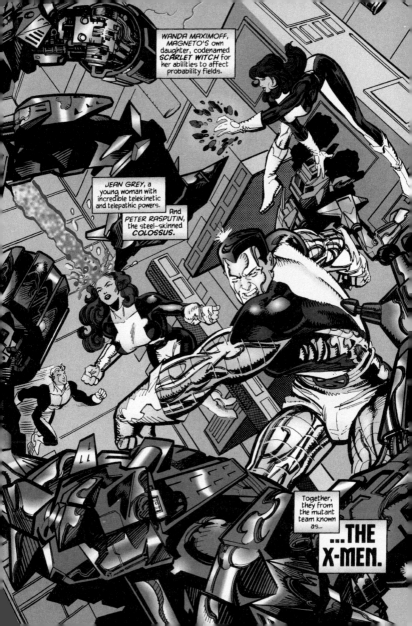

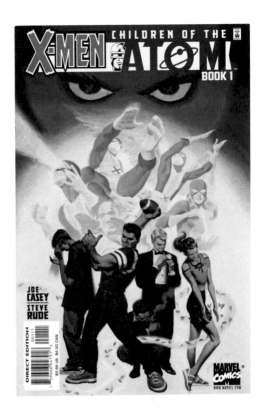

X-MEN CHRONICLES No. 1

Previous spread: *Interior: "Origins"; script, Howard Mackie; pencils, Terry Dodson; inks, Klaus Janson; March 1995.* For four months, the "Age of Apocalypse" crossover wiped out all previous continuity—in a world where Professor X died, Magneto leads a very different X-Men against the tyrant Apocalypse.

WOLVERINE/GAMBIT: VICTIMS No. 1

Opposite: *Interior; "Victims Part One: In Harm's Way"; script, Jeph Loeb; pencils and inks, Tim Sale; September 1995.* Years before their critically acclaimed "Colors" series, Jeph Loeb and Tim Sale collaborate on a pair of fan favorite mutants.

X-MEN: CHILDREN OF THE ATOM No. 1

Above: *Cover; art, Steve Rude; November 1999.*

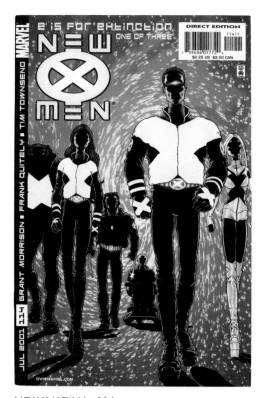

NEW X-MEN No. 114

Above: *Cover; pencils, Frank Quitely; inks, Tim Townsend; July 2001.* "This is a pop book…as essential as the new Eminem release or the latest Keanu movie. We can rejoin the culture here and the only way to do it…is to deliver the stuff the movies and the games can't…." —Grant Morrison

NEW X-MEN No. 115

Opposite: *Interior, "E Is for Extinction: Two of Three"; script, Grant Morrison; pencils, Frank Quitely; inks, Mark Morales and Tim Townsend; August 2001.* Morrison's "soft launch" began by crashing a nuclear-tipped Sentinel on the island of Genosha and killing 15 million poor mutant souls. Issued a few months before 9/11, it was an unintentional harbinger of things to come, and an ironic expression of creative innocence that would be hard to regain.

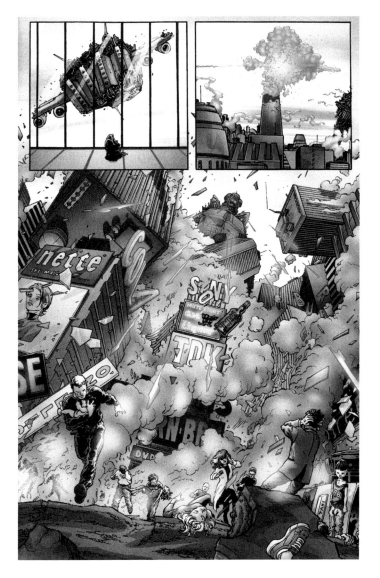

161

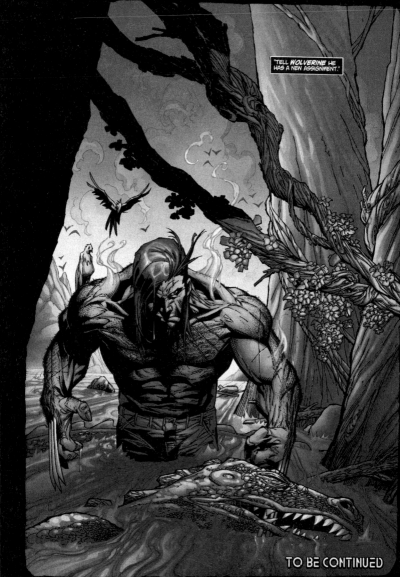

"TELL *WOLVERINE* HE HAS A NEW ASSIGNMENT."

TO BE CONTINUED

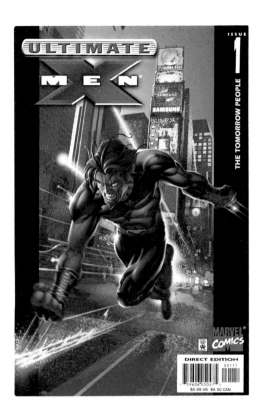

ULTIMATE X-MEN No. 1
Opposite and above: *Interior, "The Tomorrow People"; script, Mark Millar; pencils, Adam Kubert; inks, Art Thibert. Cover: pencils, Andy Kubert; colors, Richard Isanove. February 2001.* With its Ultimate Universe, Marvel reinvented some of its biggest characters for a new generation. Mark Millar's adrenaline-fueled, iconoclastic narrative gave *Ultimate X-Men* all the excitement of a box-office blockbuster.

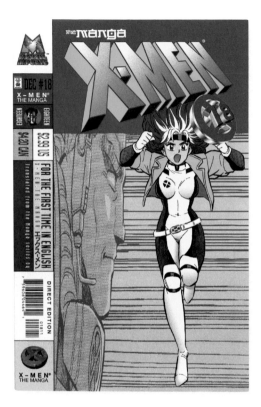

X-MEN: THE MANGA No. 18

Above: *Cover; pencils and inks, Jeffrey Huang; December 1998.*
X-Men: The Manga ran for 26 issues between 1998 and 1999,
adapting Japanese manga stories of the mighty mutants into
English for the first time. Like the team's roster itself, the
X-Men had become a truly global phenomenon.

X-MEN UNLIMITED No. 34

Opposite: *Cover; pencils and inks, Christina Chen; June 2002.* In
turn, the Japanese manga art form was having an increasing
influence on American comic books—as demonstrated on this
cover featuring a prominent Asian American X-Man, Jubilee.

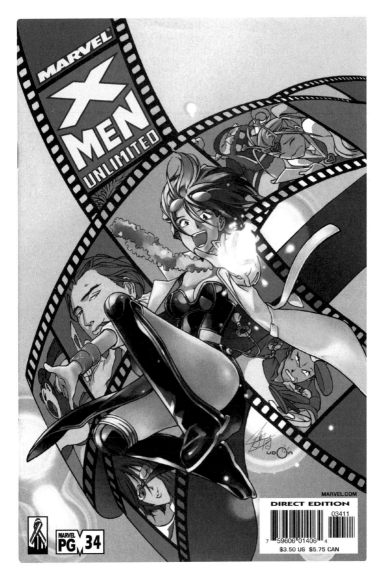

MARVEL.COM

165

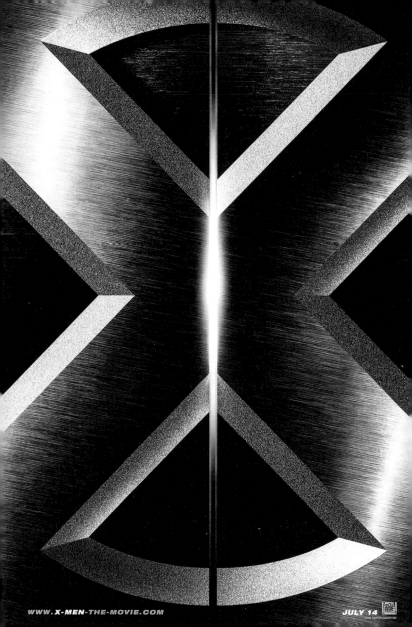

WWW.X-MEN-THE-MOVIE.COM

JULY 14

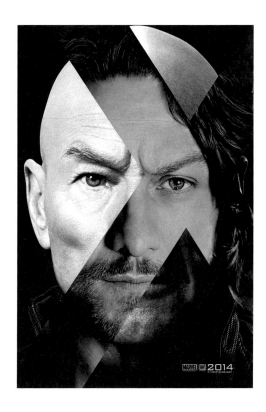

X-MEN THE MOVIE

Opposite: *Poster*, X-Men, *20th Century Fox, 2000. The 1998*
movie *Blade* proved that a Marvel property could succeed
enormously at the box office. Two years later, the *X-Men* film
would be even more of a success, with ticket sales of almost
$300 million. A tentpole franchise was born.

X-MEN: DAYS OF FUTURE PAST

Above: *Poster*, X-Men: Days of Future Past, *20th Century Fox,
2014.* Blending two generations of X-Men film stars, *X-Men:
Days of Future Past* featured Professor Xavier (played by
older Patrick Stewart and younger James McAvoy) and their
respective bands of X-Men protecting their timelines from
the dystopian future outlined in the original Claremont/Byrne
comic book storyline.

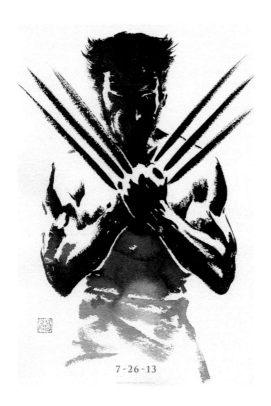

7-26-13

THE WOLVERINE

Above: *Poster,* The Wolverine, *20th Century Fox, 2013.* You didn't expect Wolverine to be any less popular at the movies than he was in comics, did you? Hugh Jackman's Logan was the breakout star of the X-Men films, earning his own quadrilogy of solo films, including 2013's *The Wolverine,* which shed light on his background in Japan.

X-MEN: AGE OF APOCALYPSE

Opposite: *Poster,* X-Men: Age of Apocalypse, *20th Century Fox, 2016.* '90s-era X-Men finally made it to the movies in *X-Men: Age of Apocalypse.* Mystique, played by superstar Jennifer Lawrence, gets her turn to lead the X-Men against the genocidal mutant demi-god, Apocalypse.

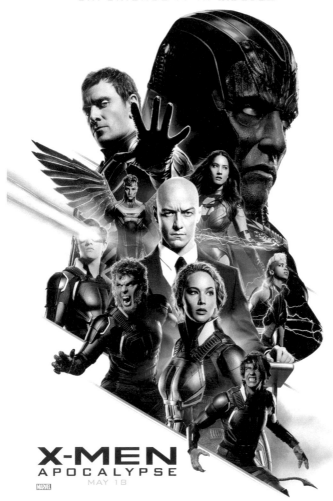

EXPERIENCE IT IN **IMAX 3D**

X-MEN
APOCALYPSE
MAY 18

MARVEL

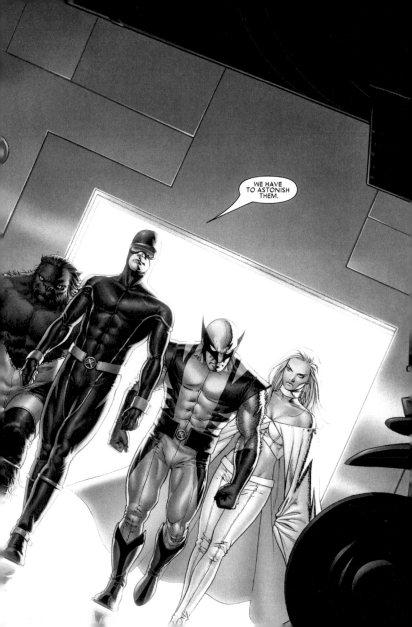

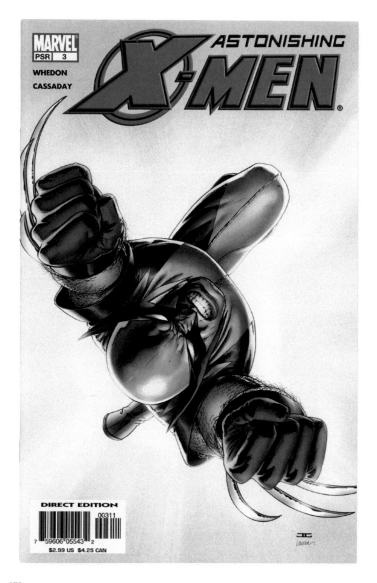

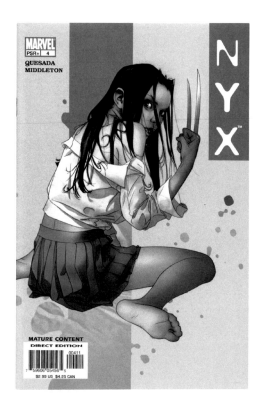

ASTONISHING X-MEN No. 1
Previous spread: *Interior; "Gifted, Part 1"; script, Joss Whedon; pencils and inks, John Cassaday; July 2004.*

ASTONISHING X-MEN No. 3
Opposite: *Cover; pencils and inks, John Cassaday; September 2004.*

NYX No. 4
Above: *Cover; pencils, inks, and colors, Josh Middleton; July 2004.* Laura Kinney, code named X-23 by the secret government program that cloned her from Wolverine's tissue, premiered in the *X-Men: Evolution* animated series before debuting in comics in *NYX*.

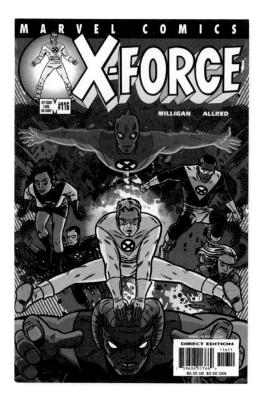

X-FORCE No. 116

Above: *Cover; pencils and inks, Mike Allred; May 2001.* Same title but offbeat new attitude. Seeking to shake up a stale line of X-Men comics, quirky creators Peter Milligan and Mike Allred were recruited to transform *X-Force* into a playground for their irreverent sensibilities.

X-STATIX No. 7

Opposite: *Cover; pencils and inks, Mike Allred; March 2003.* After 14 issues of *X-Force*, the series was rebranded *X-Statix*. The cast included unconventional mutants like Phat, Dead Girl, U-Go Girl, and Vivisector. Writer Milligan even wanted to cast the ghost of Princess Diana as a member of the group, but plans were scotched after negative reaction from British media.

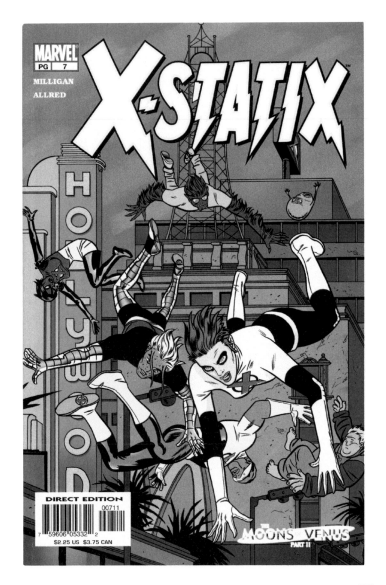

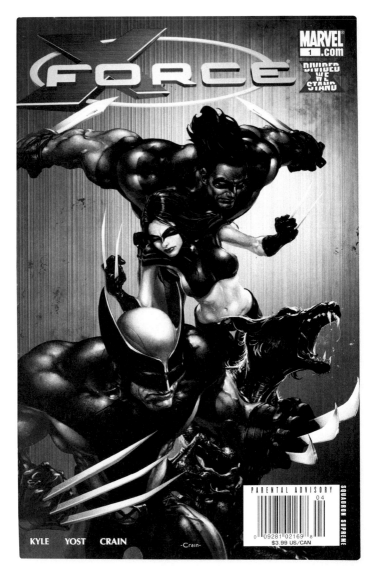

X-FORCE No. 1

Opposite: *Cover; art, Clayton Crain; April 2008.* After the Milligan/Allred take had run its course, it was time to revive the original X-Force concept of an aggressive black-ops squad of mutants — only this time with more violence and blood than ever.

X-FACTOR No. 2

Above: *Interior, "Star Power"; script, Peter David; pencils, Ryan Sook and Dennis Calero; inks, Wade von Grawbadger and Dennis Calero; February 2006.* Writer Peter David launched a new take on *X-Factor* with his 2005 series, casting the team as a mutant detective agency. The noirish action/comedy series racked up an impressive nine-year run and was home to characters like Strong Man, Monet, Rictor, and Layla Miller.

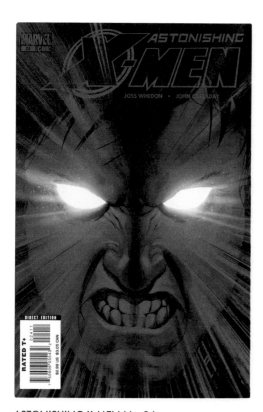

ASTONISHING X-MEN No. 24

Above: *Cover; pencil and inks, John Cassaday; March 2008.*
Whedon and Cassaday's *Astonishing* was contained in
24 issues and a *Giant-Size* finale issue. Despite serious
scheduling bumps, the saga pumped up the flagging X-Men
franchise with its creative star power and high-concept
storytelling. Colossus was brought back to life, Kitty Pryde
was lost in outer space, and the alien protection agency
S.W.O.R.D. was debuted.

UNCANNY X-MEN No. 401

Opposite: *Cover; pencils, Ron Garney; inks, Mark Morales;
February 2002.* Joe Casey and Ron Garney joined several
other Marvel creators in the "'Nuff Said" event, in which
stories were told with no dialogue.

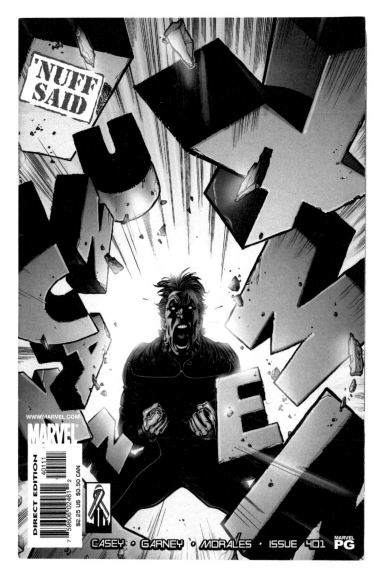

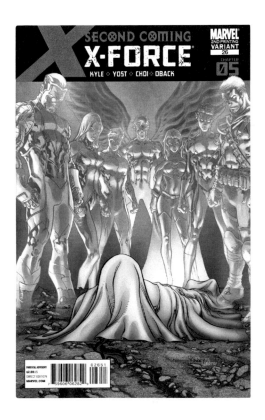

UNCANNY X-MEN No. 390
Opposite: *Interior, "The Cure"; script, Scott Lobdell; pencils, Salvador Larroca; inks, Scott Hanna, Danny Miki, Lary Stucker, Tim Townsend, Dexter Vines; March 2001.* Colossus dies stopping the mutant-killing Legacy Virus in *X-Men* No. 390.

X-FORCE No. 26
Above: *Variant cover; pencils and inks, Mike Choi; June 2010.* X-Men crossovers came back into vogue in the mid-'00s. In "Second Coming," which tied together five ongoing *X-Men* series, the decimated world of mutants reckoned with the return from an alternate timeline of Hope Summers, the alleged "savior of mutantkind" from the "Messiah Complex" event.

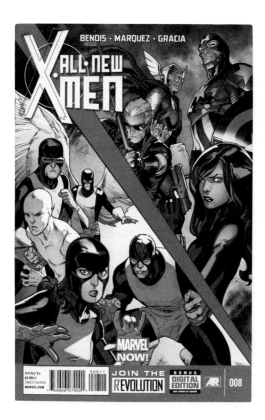

ALL-NEW X-MEN No. 8

Above: *Cover; pencils, Stuart Immonen; inks, Wade Von Grawbadger; May 2013.* The man who reinstated the Avengers as Marvel's cornerstone franchise took over the X-Men universe. Brian Michael Bendis's novel approach brought the original five X-Men — still unproven teenagers — forward in time to coexist with the contemporary X-Men.

UNCANNY X-FORCE No. 5.1

Opposite: *Cover; pencils and inks, Simone Bianchi; May 2011.* X-Force was revived again, with writer/artist team Rick Remender and Jerome Opeña launching the series as a grand epic with high drama and stark violence.

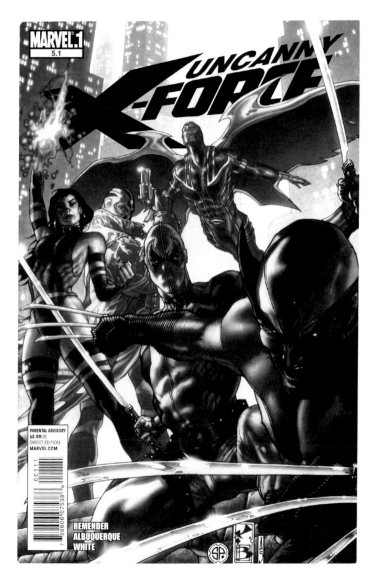

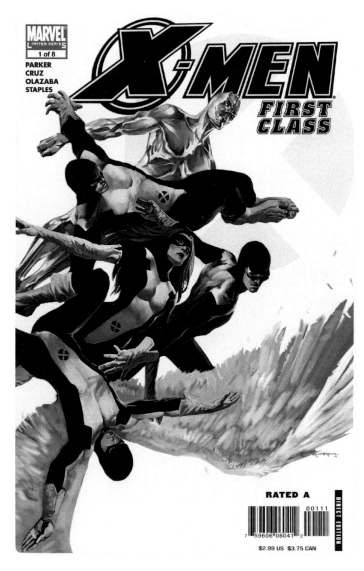

X-MEN FIRST CLASS No. 1

Opposite: Cover: pencils and inks, Marko Djurdjević: November 2006. Before there was a movie of the same name, there was a sweet-natured series depicting the original quintet of X-Men in their early days of learning their powers at the Xavier School.

ASTONISHING X-MEN No. 51

Below: Cover: art, Dustin Weaver: August 2012. New York retailer Midtown Comics celebrated the wedding of Northstar and Kyle by holding its very own ceremony for a competition-winning couple of lucky fellas. The comic and surrounding marketing reaffirms the maturity of today's crop of comics readers.

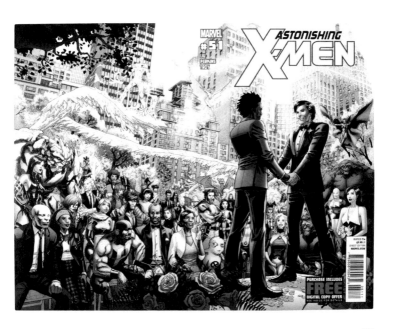

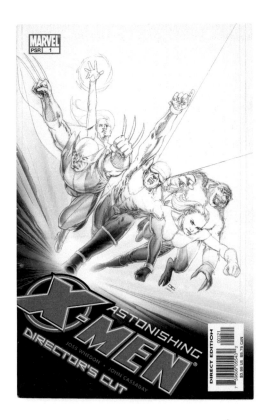

ASTONISHING X-MEN DIRECTOR'S CUT No. 1
Above: *Cover; art, John Cassaday; July 2004.*

X-MEN: MESSIAH COMPLEX No. 1
Opposite: *Cover; pencils and inks, Marc Silvestri; December 2007.*

UNCANNY X-MEN No. 500
Following spread: *Variant cover; art, Alex Ross; September 2008.*
A milestone 500th issue event called for the *uncanniest*
cover of all. Alex Ross painted a glorious ensemble of X-Men
through the ages, representing 45 years of the franchise
that had come to define a comic book industry.

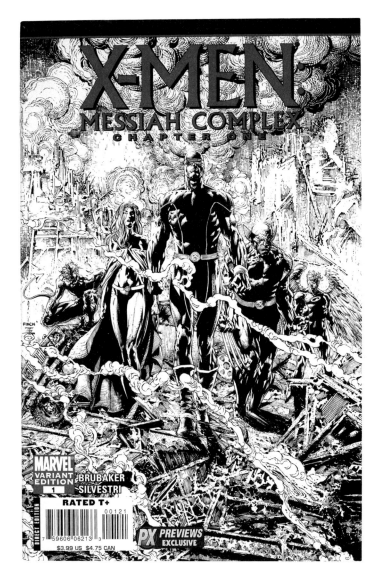

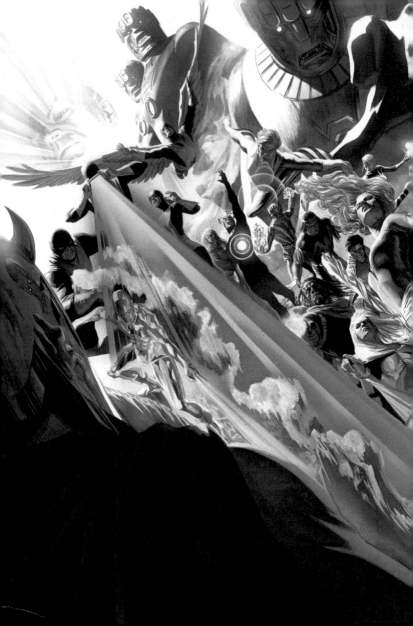

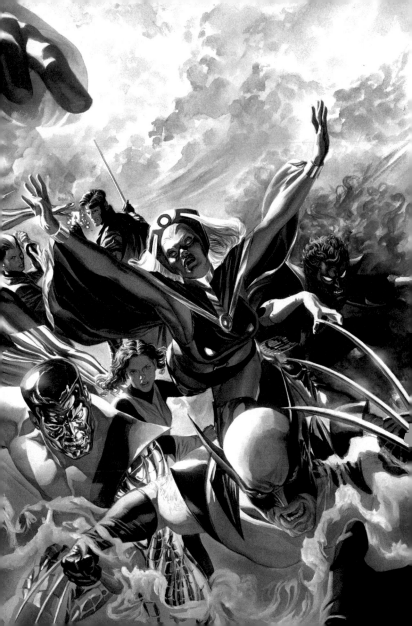

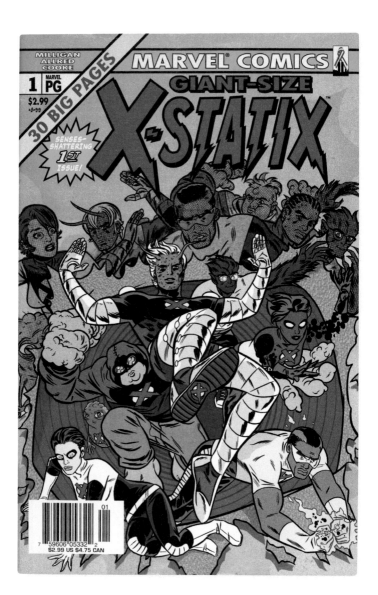

X-MEN No. 39

Front cover: *Cover; pencils and inks, George Tuska; December 1967.*

GIANT-SIZE X-STATIX No. 1

Opposite: *Cover; pencils and inks, Mike Allred; September 2002.* "Is it me…or is this popcorn, like, stale?" *Madman* creator Mike Allred's retro-cool artwork was the perfect fit for a satirical media-savvy revamp of *X-Force*, chock full of writer Peter Milligan's pop-cultural lambasting.

ALL-NEW X-MEN No. 27

Back cover: *Original art; art, Alex Ross; July 2014.*

All images in this volume are © 2018 Marvel unless otherwise noted. Any omissions for copyright or credit are unintentional and appropriate credit will be given in future editions if such copyright holders contact the publisher.

CREDITS

The majority of the comics included in this volume were photographed from the collections of Bob Bretall, Nick Caputo, Marvel, Barry Pearl, Colin Stutz, Michael J. Vassallo, and Warren Reece's Chamber of Fantasy. Also: Jesse and Sylvia Storob. AF Archive/Alamy Stock Photo: 18–19. © Eliot R. Brown: 73. Courtesy Dewey Cassell: 62. FOX Kids/Photofest: 149. John Loengard/The LIFE Picture Collection/Getty Images: 7. © Marvel/Imaged by Heritage Auctions, HA.com: 20, 31, 33, 46, 55, 63, 66, 75, 85, 92–93, 103, 109, 136, 166. © Marvel, courtesy MetropolisGallerynyc.com: 22, 50. © Marvel/Courtesy Todd Sheffer/Hake's Americana: 84. © National Cartoonist Society: 30. © Greg Preston: 141. © Ted Streshinsky: 41. TAM Collection: 38 (bottom), 44–45, 48, 167–169.

© 2018 MARVEL
marvel.com

TASCHEN GMBH
Hohenzollernring 53, D-50672 Köln
taschen.com

Editor/art director: Josh Baker, Oakland
Design/layout: Jess Sappenfield, Oakland
Editorial coordination: Jascha Kempe, Cologne; Nina Wiener and Sarah Wrigley, New York
Production: Stefan Klatte, Cologne
German translation: Reinhard Schweizer, Freiburg
French translation: Éric Andret, Paris
Editorial consultants: Jess Harrold, John Rhett Thomas, and Scott Bryan Wilson
Special consultant to Roy Thomas: Danny Fingeroth

Printed in Italy
ISBN 978-3-8365-6784-8